perceptions of

pain

dedicated to

Dr. Paula Fernandes
Graham Treacher
Susan Wright
and to the memory of my grandmother
Annice Edna Padfield

First published in the UK in 2003 by
Dewi Lewis Publishing
8 Broomfield Road, Heaton Moor, Stockport SK4 4ND
+44 (0)161 442 9450
www.dewilewispublishing.com

supported by an educational grant from Novartis Pharma AG

𝟙 NOVARTIS

ISBN: 1-904587-02-X

Design & artwork production: Dewi Lewis Publishing
Printed by: EBS, Verona, Italy

perceptions of •
pain

Deborah Padfield
Prof. Brian Hurwitz
Dr. Charles Pither
Rachel Brooks
Patrick Dixon
Stephen Dwoskin
Penny Harding
Nell Keddie
Rob Lomax
Helen Lowe
John Pates
Linda Sinfield
Frances Tenbeth
Robert Ziman-Bright

Foreword

Following the success of the critically acclaimed exhibition 'Perceptions of Pain', Novartis Pharma AG is delighted to sponsor the collation of its artwork into the book you are holding.

Owing to the uniqueness of this collection of images and testimonies, as well as our ongoing commitment to arthritis and pain management, Novartis Pharma AG is proud to be part of this educational effort. This compilation arose out of the collaboration between Deborah Padfield, artist and chronic pain sufferer, and her pain consultant Doctor Charles Pither.

Pain is extraordinarily difficult to describe, understand or share, often leaving patients feeling isolated and distraught. It is therefore extremely important for pain sufferers to be able to establish a meaningful dialogue with their doctors to convey exactly how they feel. By doing so they can ensure that the best care programmes and treatment options are discussed, which in turn could enhance their quality of life.

'Perceptions of Pain' has previously been exhibited at the Sheridan Russell Gallery, Guy's and St Thomas' Hospitals, and the Royal College of Physicians in London, as well as Novartis' headquarters in Basel, Switzerland. The exhibitions, extremely well received by the medical profession, the public and the media, were organised to raise awareness of the challenge in communicating physical pain via verbal language. By providing a visual language for pain, the photographs allowed patients and their physicians to look to new ways of communicating. The ultimate benefit of such improved communications can only be the best possible medical care and an improved life for patients.

Novartis Pharma AG would like to thank Deborah Padfield and patients for sharing, with us all, these highly emotive photographs. We would also like to thank Doctor Charles Pither, from St. Thomas' Hospital in London, and Professor Brian Hurwitz, from King's College in London for partnering with Novartis Pharma AG on this very exciting and educational initiative.

<div align="right">Novartis Pharma AG</div>

Looking at Pain

Professor Brian Hurwitz

Pain has driven people into the hands of doctors more often than any other symptom in human history. Our experience of pain is therefore foundational to medicine. So is recognition of the immensely varied ways we express and communicate it: silently in shivers, gazes, winces, and in the stretching, twisting, writhing movements of the body; acoustically in shrieks, screams or whimpers; onomatopoeically in sighs, moans and groans; verbally in strangely figurative descriptions; and socially by withdrawal from the world.

Pain generally denotes wrongness and biological unhappiness. Yet it is an evil of potentially vital importance to sustaining life. People with congenital insensitivity to pain lack protective responses to noxious stimuli, such as biological withdrawal reflexes, and suffer multiple injuries and shortened life span as a result. Hence pain is a gift nobody wants.[1]

Most frequently triggered by a stimulus causing tissue injury and spillage of intracellular chemicals, it is these chemicals which cause pain but which also initiate healing. Pain allows biological trouble and dysfunction to be fairly precisely pinpointed, promotes rest of the affected body part and application of efficacious rubs, dressings, bandages, splints and ointments. Yet other pains – particularly chronic ones – seem frequently to be maladaptive and no longer related to an ongoing noxious stimulus.[2]

To sufferers (and their carers) persistent pain seems gratuitous and meaningless, its severity and nastiness quite disproportionate to the apparently innocuous insult represented by its cause.[3] The variable relationship between underlying tissue injury and the severity of pain felt supports the view that pain can sometimes be 'a very poor reporting system'.[4] Looseness of fit between stimulus and pain has long been documented, medically, but cannot justify assuming people with chronic or unusual pain provide unreliable testimony. Time after time contributors to *Perceptions of Pain* relate how such a stance was unwarranted and caused additional distress.[5] Although pain is subjective it only happens to an 'I'.[6] By its very nature pain carries first-person authority – 'I' is the point of view from which interpretation must start. We can learn about someone's pain only by granting their testimony sovereignty; doubting a pain's veracity can threaten a pain sufferer's very identity.

The 17thC philosopher, Rene Descartes' consideration of what it means to be a self-conscious subject with thoughts and pains played a critical role in his proposal of an entirely mechanistic theory of the body and how it works.[7] But the way we perceive and speak about pain – 'my pain', 'right there, inside me!', 'no, not there – just here!' – continues to pose many difficult philosophical questions: about the nature of human consciousness, subjectivity and embodiment; concerning how bodies and mental states mesh; about whether bodily sensations, including pain, are indexical psychological states or whether they are better understood as sensory perceptions relaying information from within rather than from outside of the body.[8]

The experience of pain occupies a cardinal position in the organisation of medical knowledge and much clinical effort is directed at its characterisation. A choreography of questions - 'where is the pain?', 'what does it feel like?' 'does it move around?', 'is it constant?', 'what influences its severity?' 'when was the worst pain ever?' 'why did it happen at that time?' and 'which situations make you feel it might return as badly again?' – usually helps in diagnosis, as do descriptions, pointing and gesturing.[9,10] But some pains are not amenable to such questions, or the answers offered appear complex and indecipherable. Such pain – which may persist for many months (even years) despite a variety of treatments – can cause enormous distress and disturbances of sleep, emotion, thought and social life. This sort of pain is termed chronic pain.

Where descriptions of chronic pain fail to match recognisable patterns medical attention tends to fade, causing sufferers to feel disbelieved and invalidated.[5] Existentially, there's no objective 'pain thermometer' or single measure of chronic pain, although certain scales of pain perception have their origins in attempts to visualise its severity.[11] The clinical ability to conceptualise the position of pain depends on considerable visual literacy regarding the body, which has evolved over centuries from innumerable collaborations between artists, doctors, engravers, wax modellers, sculptors and more recently imaging engineers.[12,13] Modern X-raying and scanning technologies have enormously enhanced clinical capacities to locate otherwise hidden sites of physical mal-functioning and pain.[14]

But before the development of X-rays, clinical techniques such as tapping (percussion) and listening (auscultation) allowed doctors to envisage the interior of the body by a process of visual projection. Instruments, such as the stethoscope (root meaning: seeing into the chest), auroscope (into the ear), ophthalmoscope (into the eye), endoscope (into tubes and spaces of all sorts) emphasise the preeminence of vision in medical investigation and diagnosis.[15,16] Yet despite the transparency of human flesh to varieties of scopes, sound waves, magnetism and other fields of force, pain as felt, remains subjective.

In the past, the subjective nature of pain seems largely to have been ignored in artistic works, which portrayed pain by depicting its externally most recognisable aspects, such as bodily contortion in response to flagellation, entrapment or physical injury. Such depictions were frequently bound up with Christian iconography, in which pain signified punishment, torture and damnation,[17] martyrdoms sometimes also displaying dissociated unwordly emotions which overshadowed pictorial reference to pain.[18]

Visual portrayals of pain in medical contexts often focused on painful situations rather than on the nature and quality of pain experienced. In pictures of war wounds, amputations and the drawing of teeth, the gravity of pain is the focus – as portrayed in grimaces or the differing appearances of putrescent flesh – rather than the actual feeling of the pain felt. Charles Darwin's interest in human pain was

confined to such externalities and to what we share with animals as betrayed by similarities of facial expression, restlessness and sweating in response to pain.[19]

In the 18[th]C, subjective dimensions of human pain creep into its depiction, but formulaically, as devils wielding tongs and other sharp implements, determinedly hacking away at human flesh. Gillray's representation of the pain of gout – one of the most arresting depictions of pain in western imagery – is as a devil clasping a swollen foot, digging its fangs into an inflamed joint whilst snorting fire.[20] Despite the element of caricature this picture powerfully arouses the ferocity of gouty pain.

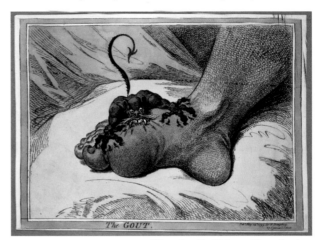

Gillray, *Gout*. The Wellcome Library, London

Historically, few depictions of pain have been produced by sufferers themselves [21,22] and the images and texts in this volume begin to correct this deficit. They result from a collaboration between professional artist, Deborah Padfield – herself a sufferer with chronic pain – and Charles Pither, a consultant in pain management, and patients undergoing residential treatment at the St Thomas' Hospital INPUT Pain Clinic in London. Funded by a Sci-Art Research Award, patients were offered opportunities to explore and co-record their experiences of pain with a professional artist, and to use a selection of their images in subsequent consultations concerning pain.

Over a period of 8 months Deborah Padfield worked closely with pain sufferers attending the St Thomas' Pain Clinic using a variety of darkroom and workshop techniques. Through a collaborative process the aim was to create photographs that represented and expressed as nearly as possible each sufferer's particular experience of pain. Deborah held one-to-one discussions with pain sufferers after which she made a series of photographs and prints to act as visual starting points in future discussions. In the week following initial contacts, patients were each encouraged to make notes, draw, and to bring objects which seemed to them related to their pain to subsequent meetings.

In a series of individual workshops images emerging from these contacts were taken through processes of deconstruction and reconstruction; they were manipulated and transformed by tearing, cutting, stitching and writing on them, the results then individually gauged against the pains personally felt.

During each session, results would be looked at, discussed, reworked and re-photographed until the images satisfied both artist and patient. Several iterations of drafting and matching against mental inner images were undertaken, during which many materials were discarded. By this means, pain sufferers were able to project the private sensations and experiences of pain – its associations, intensities, qualities and significance – outwards on to the publicly accessible surfaces of canvasses and photographic plates.

The rawness of their images grates on our senses. They remind us that pain not only hurts and demands relief, it also scares, baffles, enrages, isolates, resists medical treatment and demands interpretation.[23] Aglow with feeling, sensation and emotion, these images offer testimony to an impulsive human need to transmit unpleasant, inner experiences away from the self and outwards towards others. The resulting images do not so much depict pain as express it; they help, thereby, to objectify pain.

In some schemas of understanding seeing comes before words.[24] It is therefore not surprising that much clinical work can be clarified visually.[25] Recalling a deaf and mute woman with a longstanding headache, a neurologist described what happened when he suggested she draw her pain: 'her headache had been present for over 40 years, since the age of ten, was getting worse, was present all the time and the treatments do not work and no one listens or cares'. Like many doctors before him, this doctor believed her headache to be migraine and offered an anti-migraine medication. But on seeing her again she was obviously no better: 'her husband was sullen and glowering. She was tearful and handed me a note about how nothing had worked. It dawned on me I had not thought of conducting the interview with notes and diagrams. Slowly and laboriously she drew her headache for me – it was continuous but fluctuated in severity. It was always left sided and never crossed the mid-line. She had previously considered suicide because of the pain...The history now sounded like hemicrania continua in which case the headache should respond to indomethacin. She agreed to try it. Four weeks later she looked transformed.'[26]

In this report, recourse to drawing was clearly suggested by difficulties in communicating, but the case shows how symptom visualisation can be crucial to diagnosis and effective treatment. Pictorial representation of symptoms is not new – in the 18[th]C, when consultations were conducted by mail, sometimes across great distances, doctors who practised such 'epistolary medicine' sent patients drawings of the human body and requested they be returned, together with details of their complaints marked on the drawings to indicate the intensity and distribution of pain and other complaints, and such techniques continue to be used in modern-day pain clinics.[27] Pictures of headaches drawn by children attending a neurology clinic have been found helpful in distinguishing migraine from non-migrainous headache, diagnostically predictive features being pictorial elements suggesting a pounding quality, nausea or vomiting, wanting to lie down, avoiding light or loss of visual field.[28]

Perceptions of Pain reminds us that visualisations can play a role in medicine beyond that of illustration, to include expression and treatment as well. Already recognised in certain clinical fields, such as child development and educational psychology, depicting and interpreting experiences and symptoms visually can offer valuable information to overall assessment of wellbeing. Moving beyond a role in diagnosis, visual re-presentation has been found helpful in treating phantom limb pain. Mirrors placed in front of an amputated limb can be so positioned as to reflect back an image where the absent limb should be (because of apparent left-right transposition) and this can lessen phantom pain,[29,30] and the artist, Alexa Wright, has successfully worked with phantom sufferers using digital technology to help them visualise and produce images of their phantoms.[29,31]

The photographs in this volume transmute pain experiences into visual ones and they have impressed and moved undergraduate medical students.[32] To date, most UK medical schools lack formal curricula in pain studies. Given the prevalence of chronic pain at any moment in time – 15-20% of the population are sufferers[33] – its disabling effects on mood, lifestyle and employment, and the frequent reports concerning under-treatment in many different contexts, [4,34,35,36] the development of undergraduate courses in pain is sorely needed. In any such curriculum this volume should top the reading list.

The images collected here are inter-subjective manifestos that assert the determination of pain sufferers to control and communicate their experiences.[37] Although pain is intangible and subjective it is emphatically not unshareable; these images offer vivid testimonies to the simultaneous importance in clinical medicine of careful observation by doctors as well as recognition by them of the plight of their patients. These images should galvanise clinicians into ensuring that NHS managers and planners accord the resources required for appropriate medical treatment of pain.

Visualisation in science and medicine (observation, inspection, representation and model formation) has long been highly prized.[38] In the 16thC, anatomists and artists, alike, in furthering understanding of the human body, advanced the importance of careful looking. Leonard da Vinci counselled students and investigators 'not to encumber yourself with words... do not busy yourself in making enter by ears things which have to do with eyes, for in this you will be far surpassed by the painter.'[39] In the same period, the Bolognese anatomist and surgeon, Berengario da Carpi urged anatomists not to believe anything in this discipline 'simply because of the spoken or written word: what is required here is sight and touch.'[40] For his powers in these respects the discoverer of the circulation of blood, William Harvey, was hailed as 'that Ocular Philosopher and Singular discloser of truth,'[41] and exceptional powers of visualisation on the part of Alexander Fleming were crucial to his discovery of penicillin.[42]

The contributors to this volume add a new strand to the tradition of visualisation in medicine which allows pain sufferers and clinicians to glimpse aspects of

pain – life's dreaded companion – previously repressed and unseen.[43,44] The pools of light and colour they have created focus the thoughts and feelings of viewers. To perhaps familiar qualities of pain, such as hot, cold, sharp, blunt, visceral stretching, invasion, eruption, grittiness and crushing – they add those associated with claws, cement, rubbish tips and cogs, in composite images which stare out at us from dark backgrounds.

Artist, Deborah Padfield, patients of the St Thomas' Pain Clinic and its consultant, Charles Pither, are bringing pain out into the open. Their pictures demonstrate the role which imagination can play in the practice of medicine, allowing re-arrangements of thoughts, ideas and sense data and re-conceptualisations of mental images. Imagination enables patients to depict their inner experiences and it empowers health care professionals visually and emotionally to grasp the nature of painful experience. This collaboration is ingenious and unique and its resulting images will help to improve the recognition and care of pain sufferers.

Professor Brian Hurwitz MD FRCP FRCGP
D'Oyly Carte Professor of Medicine and the Arts
King's College, London.

References

1. Le Fanu J. Introduction. In: Klein AC. *Chronic Pain*. London: Constable & Robinson Ltd 2001.
2. Woolf C, Mannion J R. Neuropathic pain: aetiology, symptoms, mechanisms, and management. *Lancet* 2001 S1 357.
3. Melzack R. *The Puzzle of Pain*. Harmondsworth: Penguin 1973.
4. Morris D. *Illness and Culture In the Postmodern Age*. Berkley: University of California Press 1998, 107-34.
5. Padfield D. Believing is seeing. *Clin Med JRCPL* 2002;2:571-2.
6. Blackburn S. *Think*. Oxford: OUP 1999.
7. Duncan G. Mind-body dualism and the biopsychosocial model of pain: what did Descartes really say? *Journal of Medicine and Philosophy* 2000;25:485-513.
8. Burmudez JL, Marcel A, Eilan N (eds). *The Body and the Self*. Massachusetts: The MIT Press 1998.

9. Bayliss R. Pain narratives. In: Greenhalgh T and Hurwitz B (eds). *Narrative Based Medicine*. London: BMJ Books 1998, 75-82.

10. Launer J. *Narrative-based Primary Care*. Oxford: Radcliffe Medical Press 2002.

11. Good M-J D, Brodwin PE, Good B and Kleinman (eds) *Pain as Human Experience*. Berkley: University of California Press 1994.

12. Petherbridge D and Jordanova L. *The Quick and the Dead*. Manchester: National Touring Exhibitions 1997.

13. Jordanova L. Gender, Generation and Science: William Hunter's Obstetrical Atlas. In: Jordanova L. *Nature Displayed*. London: Longman 1999, 182-202.

14. Ghanem AN. Flank pain, heamaturia and urinary tract infection: time to upright patients, images and issues? BMJ.com/cgi/eletters/324/7335/454.

16. Couser GT. *Recovering Bodies. Illness, Disability and Life Writing*. Wisconsin: University of Wisconsin Press 1997.

17. Spivey N *Enduring Creation: Art, Pain & Fortitude*. Thames & Hudson 2001.

18. Mills R. A man is being beaten. *New Medieval Literatures*. 2002;5:115-53.

19. Darwin C. *The Expression of the Emotions In Man and Animals*. London: John Murray 1872.

20. Godfrey R. *James Gillray. The Art of Caricature*. London: Tate Publishing Ltd 2001.

21. Sacks O. *Migraine: Evolution of a Common Disorder*. London: Pan Books 1981.

22. Spence J. *Putting Myself in the Picture*. London: Camden Press 1986.
 See also *The Picture of Health. Alternative Approaches to Breast Cancer* (Exhibition) and *Phototherapy* hosted.aware.easynet.co.uk/jospence/ (accessed 2002).

23. Morris DB. *The Culture of Pain*. California: University of California Press 1993.

24. Berger J. *Ways of Seeing*. London: BBC and Penguin Books Ltd 1972.

25. Davies B. A picture is worth a thousand words. *BMJ* 2002;325:1298.

26. Le Fanu J. *They Don't Know What's Wrong*. London: Constable & Robinson Ltd 2001,10.

27. Ohnmeiss DD. Repeatability of Pain Drawings in a Low Back Pain Population. *Spine* 2000;25:980-8.

28. Stafstrom CE, Rostasy K, Minster A. The usefulness of children's drawings in the diagnosis of headache. *Pediatrics* 2002;109:660-72.

29. Shenker NGN, Blake DR. Understanding pain: the enigma of pain and suffering. *Clin Med JRCPL* 2002;2:574-7.

30. Halligan PW, Zeman A, Berger A. Phantoms in the brain. *BMJ* 1999;319:587-8.

31. http://www.sciart.org/site accessed January 2003.

32. Pither C. Finding a visual language for pain. *Clin Med JRCPL* 2002;2:570-1.

33. Blyth FM, March LM, Brnabic AJM, Jorm LR, Williamson M and Cousins MJ. Chronic pain in Australia: a prevalence study. *Pain* 2001;89:127-34.

34. Larue F, Fontain A, Colleau SM. Underestimation and undertreatment of pain in HIV disease: multicentre study. *BMJ* 1997;314:23-8.

35. Mayor S. Survey of patients shows that cancer pain still undertreated. *BMJ* 2000;321:1309.

36. Charatan F. Doctor disciplined for 'grossly undertreating' pain. *BMJ* 1999;319:728.

37. Scarry E. *The Body in Pain*. Oxford: OUP 1985.

38. Miller IA. *Imagery in Scientific Thought*. Mass: The MIT Press 1986.

39. Leonardo da Vinci. Quoted in: Roberts KB and Tomlinson JDW. *The Fabric of The Body*. Oxford: Clarendon Press 1992, 101.

40. Berengario da Carpi, *Commentario* Folio Viv 1521, quoted in: Carlino A. *Books of the Body*. Chicago: University of Chicago Press 1994, 25.

41. Lord Brain. *Doctors Past and Present*. London: Pitman Medical Publishing Company Ltd 1964, 1-7.

42. Macfarlane G. *Alexander Fleming*. Oxford: OUP 1984.

43. Wahrborg P. Pain – life's dreaded companion. Cultural history of algology and the most important achievements. [Translated from Swedish] *Lakartidingen* 2001;98:1642-6.

44. Perkins, J. *The Suffering Self: Pain and Narrative in the Early Christian Era*. London: Routledge 1995.

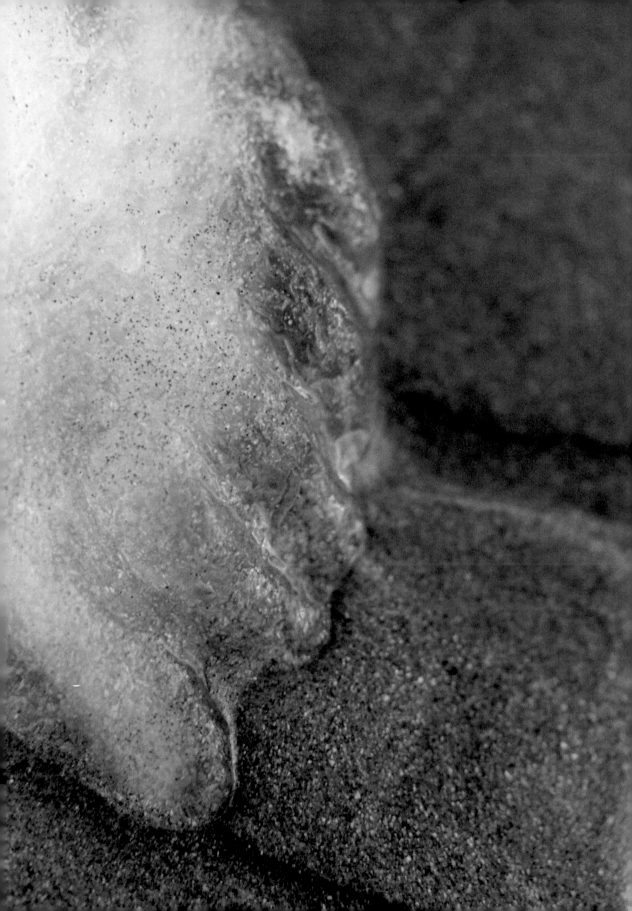

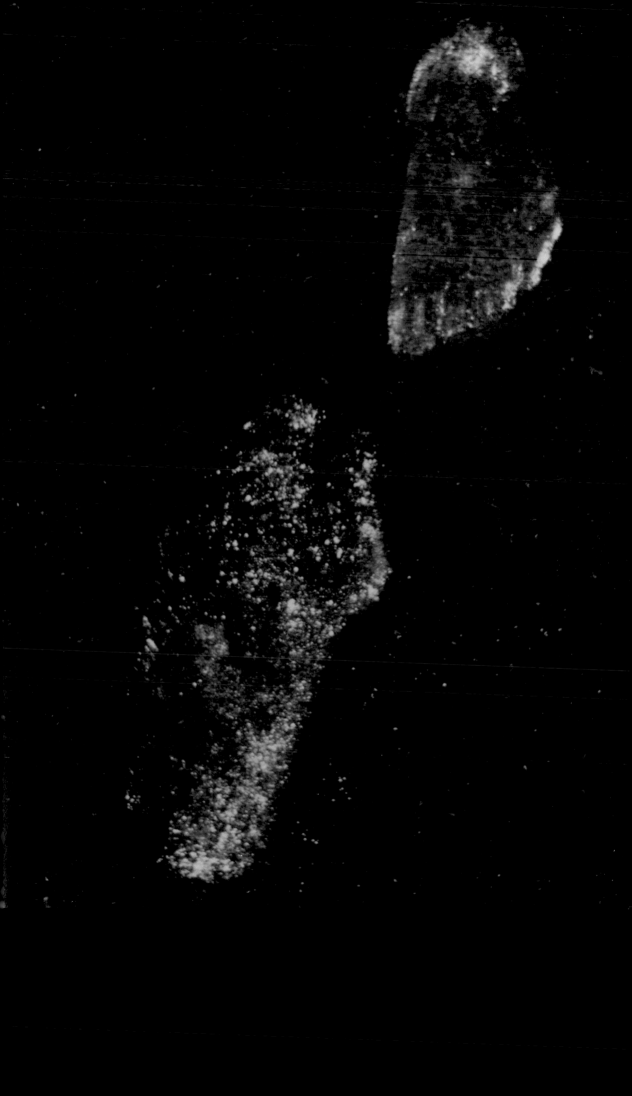

In search of a
Visual Language for Pain

Deborah Padfield

A puzzle

Whatever pain achieves, it achieves in part through its unsharability, and it ensures this unsharability through its resistance to language... to have great pain is to have certainty; to hear that another person has pain is to have doubt. [1]

The challenge that pain makes on language is inextricably bound up with the demands it makes on our ability to move beyond our individual experience and empathise with that of another. In a medical setting this poses specific problems. How do you arrive at successful diagnosis or management of 'pain' when there is no shared language to agree on what 'it' is? 'It' elicits quite different responses from doctors and from patients. 'It' remains undefined and frequently becomes a battleground.

I have always found it hard to explain my pain to doctors. You have to explain it to them so that they can understand it, and it doesn't matter how often you try to explain it to them, they still don't understand. (Rob, in-patient, INPUT)

You can't see pain, so people don't believe it. I had that even more so with doctors. One doctor sat there and said, "You cannot be in the pain you say you are in," I said, "What do you want me to do to show you I am in pain?" (Rachel, in-patient, INPUT)

Doctors are faced with pain and unhappiness they can neither cure nor afford to empathise with on a daily basis. Patients feel disbelieved and prepared to go to the ends of the earth to seek out further avenues of treatment. We are creating a culture of 'demonstration' and 'distance', retreating behind different shields as if in conflict.

From talking to Dr. Charles Pither and his colleagues at INPUT, pain management unit, St Thomas' Hospital, I discovered that many medical professionals are as frustrated as patients by pain's resistance to language.

Where then do we look for an answer?

What is it we are looking for?

A dark isolated place

It is not only to doctors that chronic pain patients find it difficult to articulate what they are experiencing, but to family and friends. The place this leaves them is often lonely and unreachable by those outside it. One sufferer described how he was unable to talk about his pain even to those closest to him. His experience of 'self' disintegrated and he withdrew so far that he became *trapped in a dark and isolated space.* (Patrick, in-patient, INPUT)

Most of the sufferers I worked with describe the space they inhabit when the pain is severe in terms of blackness, emptiness and aloneness. It is reflected in the images produced, many of them portraying objects floating in, or isolated, within a black space. The associated feelings are frequently of fear and being out of control.

I feel like I am suspended, in freefall and in a dark place, not knowing when it is going to pass... When you have pain you are stuck in a dark cocoon and you suffer in your own darkness. Pain = Evil; Evil = Darkness; Darkness = Pain. (Rob, in-patient, INPUT)

What is it that this darkness represents? It seems as though it takes us back to a primal space where words have not yet formed. It leads us to the space where Elaine Scarry places pain, 'anterior to language, to the sounds and cries a human being makes before language is learned'. [2]

It requires a language which works on a more instinctual and primal level than words. One such language, is visual language – with its ability to contact the unconscious in maker and viewer. This is where I feel we should be looking when we search for a bridge between the private suffering of an individual and a medical and collective understanding.

A journey begins

This is not a journey to which I am a stranger. Nine years ago I was disabled by chronic pain following unfortunate surgery and aftercare. The world as I knew it became thrown into question. My own place within it began to dissolve, reality took on the shape of shadows and everything had to be renegotiated on new terms. What had previously been certainties disintegrated in front of me and I was at a loss to make any sense of this new world at all.

The immediate recourse when pain is overwhelming is to attempt to run away from it, to try various distraction techniques. This did not really work for me because the pain always came along too. My GP is one of the people who helped prevent a complete dissolution of my own sense of reality and identity. In contrast to ignoring the pain, she encouraged me to confront it – to write about it, to draw it, and to send these responses to her. With enormous patience and perception she discussed them through subsequent consultations. I see this as having had two benefits for me. Firstly, it made tangible and externalised something of my inner experience of pain, thus reducing the intensity of my personal relationship to it. Secondly, it enabled me to look more objectively at aspects of it and begin to disentangle some of the elements which by then had begun to form a very complex picture. The original physical trauma was easy to point to, but the significance it held for me and the complex processes at work as I responded with anger, and eventually depression, to the collapse of my world, were not. It became a self-perpetuating cycle of increasing pain and despair. At that point I did not need someone telling me the pain was appropriate or inappropriate – I would not have listened. I listened to the observations of my GP because I felt she had accepted what I was actually experiencing rather than what I should be experiencing and trusted my ability to be partly responsible for my own recovery. It began a slow shift in my understanding of, and relationship to, pain.

For similar reasons, I was able to trust a second surgeon enough to re-operate. I still feel that she was able to reach the diagnosis she did because she had listened so carefully to my 'narrative', gleaning what she could from it without seeing it as irrelevant, and then using her considerable skill as a surgeon to interpret and diagnose correctly. The surgeons at the initial hospital had both repeatedly failed to listen to me and to diagnose correctly.

These examples of excellent medical care made me aware of several things: the importance of good communication between patient and doctor; the need for patients to accept some responsibility for their own recovery, and the potential resource visual images can provide in the health setting.

A project is born

Being unable to continue my original career in the theatre, I had to find another which was less physically demanding. I retrained in Fine Art and was lucky enough to attend incredibly supportive institutions where I had the freedom to explore issues of the body and pain within a creatively stimulating structure. It seemed no accident that every sculpture, drawing, and painting I produced, succeeded better as a photograph. I began to realise that having spent so long on the passive receiving end of the medical gaze, it was through photography and an active control of the lens, that I was regaining a sense of control over my world. I was using photography as a way of regaining ownership of my own body and its experiences. Was it possible that a similar process could be useful to other people with chronic pain?

I discussed this idea with my pain consultant, Dr. Pither, and learned that he was interested in the role visual images might play in improving communication between doctor and patient. He was also interested in their potential for increasing the accuracy of the existing pain drawing [3]. I was interested in the potential to return to patients some control over how their pain is seen and understood, as well as the potential for them to initiate and improve dialogue. In addition to the space between doctor and patient, I was interested in exploring the relatively unchartered territory between photographer and subject. After testing the ideas on artists known to us who suffered from pain such as Stephen Dwoskin and Nell Keddie, and following many further conversations with Dr. Pither and his colleagues at INPUT, a project emerged.

I had come across a consultant who was courageous enough to experiment with such a project within an established medical setting, and a unit willing to support it. The challenge, as Professor Hurwitz points out, was not to make sharable the external ravages or indications of pain, but something of the internal invisible qualities inherent to individual pain. A Sciart grant enabled us to start researching with chronic pain patients, the possibility of creating 'a visual language for pain'.

The photograph

I believe the need to prove its existence increases a person's experience of pain, trapping them within one of the few certainties left to them. The pain has to keep existing, because it has reached a point where if there is a moment when it does not appear to exist, then the horrible possibility is raised that it might never have existed at all! If the pain that was so debilitating was never real, what else in the world is also unreal? A person's experience of the outside world becomes more and more detached at this point while their relationship with their confusing and shifting internal world becomes more and more intense.

If pain can be trapped within an external representation such as a photograph, instead of within the body, then it passes from a private hidden individual space into a visible, public and collective space. Once that photograph has been seen and accepted as 'real' by others, the sufferer no longer has to prove the existence of the pain and the pain is reduced.

I feel the images we produced reduce the pressure on me to prove my condition to sceptics thus reducing an element of tension which can contribute to exacerbation. (Linda, in-patient, INPUT)

In this way, a subjective experience is objectified and a shared reference point provided from which patient and doctor can work together to disentangle aspects of the pain depicted.

In *Camera Lucida*, Roland Barthes describes the photograph itself as a wound. *I wanted to explore it [the photograph] not as a question (a theme) but as a wound: I see, I feel, hence I notice, I observe, and I think.* [4] Through his description of what he terms the 'punctum' he attributes similar qualities to photography as to medicine. At times (occasionally the same time as with fibre optics, X-rays etc.) both practices attempt to make visible what has hitherto been invisible – to peel back the skin revealing what is usually concealed, and often painful.

It is no accident that the photograph was the form selected for the images. The photograph carries with it – albeit erroneously – connotations of 'truth'. In reality, the 'truth' conveyed is largely selected by the photographer, who becomes the architect of how the 'object' photographed is seen or interpreted. In medicine as much as in photography, what is seen and how it is interpreted is dependent on the context in which it is viewed. It is affected by the ideological position of the viewer, the assumptions they make based on their cultural, religious, or racial background; what information is selected, what is omitted etc. If patients were given some control over a medium such as photography (with its own inherent power structure) and that medium was then placed within an existing power structure, such as the current medical model, there could be potential for an interesting, if uncomfortable, shift. That is, if patients select what is viewed and its context, it might provide a more equal and mutually beneficial starting point for dialogue: highlighting the most distressing part of pain for that patient.

In a follow-up consultation with Rachel, using the photographs she had selected, Dr. Pither remarked that the body and the physical site of her pain were entirely absent from the group of images she brought him. This led into a conversation about what she needed to express emotionally at that point, in preference to describing the physical embodiment of the pain. With other sufferers the images directed the conversation towards physical details of their pain such as 'ants under the skin', burning points or constraint, such as a 'straight jacket' would inflict. With most people it covered both physical and emotional elements of pain.

By connecting us to an unconscious or pre-verbal part of ourselves, but translating that part into an objective, 'readable' object, the photograph simultaneously brings us closer to our experience, and distances us from it – thus serving a function that I don't think another image form would have done. Susan Sontag [5] speaks of the emotional detachment the aesthetics of a photograph can promote, and the dangers of aestheticising painful experiences. These photographs were not driven by only aesthetic decisions – far from it – but the distancing they effect may be of direct benefit to us here, allowing us to look at aspects of ourselves, and experiences, which have hitherto been too painful to acknowledge. Helen chose to photograph her arm, where cuts from self-harming were clearly visible. By photographing the cuts she was photographing what was already a visual sign of her inner pain, but it was only by looking at the photograph of her arm, rather than her arm itself, that she was able to say: *Seeing the photographs made me realise what I had done to myself.* (Helen, in-patient, INPUT)

The choice was given to her, whether she exhibited this image or not. She was not only able to look at a 12" x 16" print in an individual consultation but also to face the same image printed a metre square exhibited in a public space. It is impossible to imagine what courage it takes to do that, and she herself observed how far she had come to be able to do so without it creating further distress.

I want to show my scars because I know there must be other people with pain who have felt as desperate as I have... I use self-harm as a way to control the pain. (Helen, in-patient, INPUT)

This brings me to the last aspect of the photographs: that they and the experiences they depict needed to be validated by being publicly seen and experienced. One reviewer wrote in the BMJ:

Viewing the pictures was a numbing and uncomfortable experience for me. Perhaps that is a typical doctor's reaction... faced with something too hard to understand and to which I felt I had no answer, I wanted to shut off. But somehow these pictures wouldn't let me. Perhaps it was something to do with the courage that it must have taken to create them, but I found it impossible to turn away as the profession has turned away from such people in the past.

There is a physical as well as an emotional or intellectual response evoked by standing in front of an image of pain, one metre high. As a viewer you almost

enter into that space, its bleakness bears down on you, but as you turn to move on to the next one there is the awareness that you are able to walk away. The sufferer, like the image, is trapped within that frame, until a way is found of dissolving it.

My 'role'

I was clear at the beginning that I was there as a photographic artist and fellow pain sufferer, not as an art therapist, or someone who had found any resolution to their pain. Although many of the volunteers describe having found the process therapeutic, it was not because of any attempted psycho-dynamic relationship. It was the freedom of exploring their own narratives visually, the release experienced in making visible what had hitherto been invisible, and the inherent therapeutic effect of the creative process which they described enjoying.

I enjoyed the freedom that was given in trying to produce my pain in photographs. (Patrick, in-patient, INPUT)

I enjoyed being able to use my imagination to the full. (John, in-patient, INPUT)

I really enjoyed the hands on stuff – i.e. cutting up photos and screwing up bits of paper. I've enjoyed starting to use the camera and learning about photography in general. (Rachel, in-patient, INPUT)

I enjoyed the freedom to express without words. (Frances, in-patient, INPUT)

Just as I felt it was necessary for doctors to relinquish some of the duty of finding an 'answer', I felt it was important that I relinquished some of the authorial voice of the artist. If the process was going to have any benefits for sufferers then they had to be part of that process.

I had many discussions at this point with the filmmaker and artist Stephen Dwoskin who generously gave me the benefit of his knowledge and research into pain. We discussed the difficulties of attempting to create a language which could have meaning on an individual level and yet translate into something which could be universally understood or relevant.

There is no universal symbol because pain is individual... pain is such a complex thing to try to put into image form. It is not a single issue or image-making process, because in the end you always begin to generalise, you don't get specific pain. [6]

How could we avoid generalising, yet make symbols which signified beyond the individual? It had to be a collaborative process. I had no desire to make a language for sufferers, I wanted to make it with them. I did not want to speak on behalf of those in pain, but with them.

This left us in a boundary-less zone, somewhere between photographer and subject, with few signposts, and requiring continual renegotiation, from image to image, and person to person. In a desire not to reappropriate someone's pain –

as, in a way, I felt it had probably been appropriated somewhere down the diagnostic corridors – I attempted initially to hold back most of my own visual impulses. This put me in an unfamiliar position with no anchors. Many of the comments made by sufferers presented themselves to me as visually exciting, but if I directed the aesthetics of the images arising out of them, then I reduced the involvement and control of the sufferer. Removing all of my own visual sense or experience eventually seemed an artificial position to adopt. Often I had experimented out of curiosity with an idea and found that sufferers felt it actually came very close to what they wanted to convey.

A more sustainable relationship evolved where both our skills and interests contributed to the final images. At all times the process was collaborative and enabled the collection of photographs to arrive at an aesthetic that would not have been achieved by any one of us alone. Both as an artist and as a pain sufferer I found it an invaluable and rich process. I was very lucky with the people I worked with: not only for their motivation and creativity, but for their willingness to share their experiences in the hope that it might help others. The conversations we had during these sessions often made me look in new ways at my own pain and what it meant to me. There can be few people who can be honest enough to be almost paralysed by pain and, within a few weeks of a pain management course, ask themselves the questions many of these people did. I owe them an incredible debt of gratitude and not only for the images they helped produce.

The process

All of the sufferers we worked with had experienced an original trauma to the body and the self through accident, assault, surgery or illness. They had been suffering intense pain – for between nine and forty two years – and in the case of the INPUT patients no medical resolution has been found to its intensity and prolongation.

Following trials, we sent letters requesting volunteers to chronic pain sufferers waiting to attend a four week residential pain management programme at INPUT, St Thomas' Hospital. Those who responded met with me briefly on their pre-treatment visit to the unit, to find out more and decide whether they still wanted to participate. It was explained that they would be working with me to co-create photographs which represented as nearly as possible their individual experience of pain, and that they would be offered the opportunity of taking a selection of the photographs produced to a follow-up consultation with Dr. Pither. All of those who had shown interest did, in fact, volunteer. Had it been possible, we could have worked with most of each admission group.

There were strong motivations for taking part which seemed to be the frustration of not being able to communicate pain, a desire for doctors to understand, and an even stronger desire to help other sufferers through knowing they were not alone.

I enjoyed being able to use my imagination to help others. (John, in-patient, INPUT)

I think there are a hell of a lot of people out there who feel like this and need to know that they are not alone. (Rachel, in-patient, INPUT)

During their first week on the programme participants met with me to discuss their experience of pain: what elements of it, or its effect, they wanted to communicate, and how that might be achieved through the medium of a photograph. They were given a notebook in which to jot down texts or ideas. Despite living with considerable levels of pain, and fitting this project around an already intensive programme, patients found time not only to return with writing we could incorporate, but also with objects and photographs. At this early stage I usually searched out and photographed places or objects they had specified, and processed and printed a selection of images which could be used as starting points in subsequent sessions.

The need to convey, as accurately as possible, what they experienced, pushed the boundaries of my own practice considerably. I explored ways of printing on materials and using techniques which were new to me such as cement and concrete; printing through materials such as glass and water; combining negatives; setting fire to, or freezing, objects; integrating objects such as clocks and wires back into the photograph. Sufferers intervened in the process through stitching into, drawing onto, tearing or cutting into the photographs or at times returning with their own. By having a copystand in the room, we were able to experiment together with as many forms of photomontage as presented themselves to us, continually rephotographing, and re-collaging. We met once a week during the rest of their four week stay, and continued to deconstruct and reconstruct the images in this way, discussing them as they changed – for example exploring the difference it made if the image was colour or black and white; if certain elements were included and others omitted; if the objects were placed at a different angle, if the lighting changed, etc. The process often continued after they had left the programme with artist and sufferer meeting several times at intervals.

The sessions were taped and most of the quotations cited in this book have been taken directly from these recordings. I was particularly interested in the way in which the shared aim of creating a photograph fed into the verbal as much as the visual dialogue. Focussing on visual objects and their juxtapositions, rather than verbal histories, changed the type of dialogue possible. Through the process of image-making sufferers articulated, sometimes poetically, sometimes with alarming starkness, the conflicting and multifaceted nature of pain. One sufferer described, for example, pain's dual function for her as both a trap and a defence - stimulated by a photograph of a curtain partially obscuring a building behind it. Penny described beautifully her own experience of pain through the posture of a drooping sunflower: *It is just in agony by the look of it; I caught it on a bad day. I didn't have a very good day that day. The head is down, it just seems as though it has*

ended its life, but what it will do this year is it will shoot back up again. The roots are strong. It varies with me. This one will come up again. (Penny, in-patient, INPUT)

Robert referred to the way pain overwhelmed his consciousness as well as his body, when collaging a photograph of a submerged head into a position where it was dislocated from the body of an overflowing bath. John referred to the feeling of being out of control and subjected to an outside agent via the tightening of a jubilee clip around a tyre. Visual stimuli seemed able to provoke a type of dialogue which verbal stimuli such as 'what does your pain feel like' often doesn't. The challenge would be to see what sort of dialogue these images could initiate with a medical specialist who had not been part of the image-making process.

The response

Dr. Pither draws his own conclusions in the epilogue to this book. Feedback from the exhibitions (made possible by generous funding from the Guy's and St Thomas' Charitable Foundation) has been an important part of the process. It has encouraged us to investigate further:

As a doctor in training, I feel it will help me to understand and help my future patients.

Excellent, I have been a doctor for 14 years. I had the best insight ever into the patient's experience of pain.

I too have been guilty of some of the comments made by doctors quoted in this exhibition.

This exhibition will liberate loads of people like me who have been suffering alone.

May we all find ways to understand, communicate and deal with different types of pain in order to enhance lives.

Participants have since used the images to describe their pain to family and to friends as well as to doctors. Physicians have asked for images to trial in their own consultations with patients who have not been directly involved in their making. One such specialist writes:

I continue to experiment with the images. They are proving inspirational for patients, increasing compassion and understanding by Health Care Professionals. Several cases have been striking... I offered two images, the concrete jacket and the cards and the patient was emphatic that his back was the pack of cards and not the jacket. He leant on his hands or against the wall to support himself in case his back fell down... This probably means that if the brain's pain centres see/interpret his pain and body sensations through this image experience which is a catastrophic misinterpretation of his pain and back sensations, the pain systems will continue the pain experience and

so the pain continues and the gate control on reducing pain messages and their interpretation cannot be effective. (Dr. Frances Cole, Pain Specialist, Pain Rehabilitation Programme, Bradford Hospitals)

Dr. Cole also affirms how the images have been useful to other professionals, including physiotherapists and nurses, increasing their understanding of why patients are so afraid to move, and how they can form a potential for change.

If the images can generate greater understanding between patient and doctor this could be particularly beneficial in areas where doctor and patient do not share the same first verbal language. We are particularly grateful for the support Novartis Pharma AG has given in making the publication of this book possible so that the work can be disseminated to a wider audience.

These responses open up possibilities for future work, such as involving a therapist or psychologist to explore the issues raised by the images and extending the bank of images for use as an assessment tool in other settings.

It may also be worthwhile giving medical students a similar opportunity to explore their own invisible fears: of failure; of the future, the insides of their own bodies, etc. Access to visual processes may give them another valuable tool for understanding and communicating with their future patients.

The wider picture

In the 1980s, Jo Spence spoke clearly of the collusion in our own infantilisation that handing over our bodies to others to do what they want with them entails, and how she herself used photography to counteract the subsequent sense of powerlessness. [7]

Medicine has changed much since then, but there is still the inescapable fact that in certain situations we have to hand over our bodies to medical professionals to 'treat', sometimes to 'save'. They will always have to protect themselves from the constant barrage of human suffering they witness by some form of necessary inhumanity. [8]

However, this becomes destructive when the protective roles become so hardened that doctors and patients hide behind adopted masks or positions. The power hierarchies operating within medical institutions are no different from those operating within any other institution. Foucault described power not as something with which certain people were endowed, but as the name given to a complex strategic situation in a given society. [9]

If so, the possibility for change in the future lies as much in the hands of patients as doctors – it lies with all of us. We have to accept that we cannot demand more and more from medicine in terms of miracle cures or solutions where they do not exist. We can demand, however, that our experience of our own illness and bodies be seen as relevant to dialogue within medical practice.

Return to the puzzle

Patrick Wall and other specialists have clearly illustrated the complexity of the pain experience: *Single-purpose cells simply didn't exist. So the classical theory of pain was wrong. The point is, that the brain does not just sit there passively reading incoming pure sensations, rather it sends down controls which actually shape the incoming messages. Pain is the noticeable aspect of a series of integrated mechanisms by which the organism deals with injury, it is not a one-way signalling device.*[10]

If our understanding of the complex pain process is still incomplete, then an obvious place to look for missing pieces to the jigsaw must be the testimonies of pain sufferers.

Stephen Dwoskin observed that he thought what we were doing was *going to be a long process, it is not that you are doing the impossible, but it is that you are doing on the one hand something which is very precise and on the other hand something which is abstract. It is a contradiction. Dealing with pain is dealing with contradictions all the time. Pain is not a mystery, it is a puzzle. It is making puzzles all the time. You can't solve puzzles you just have to make them.*[11]

The testimonies which follow are puzzles. They are the result of years of pain, and of a lengthy and intensive process of image-making. They give us clues but provide no answers. Pain itself remains a puzzle. It is a puzzle which requires our acceptance of the pain of 'not knowing' as part of our shared humanity.

Deborah Padfield

Notes

1. Scarry E. *The Body in Pain*. Oxford: OUP 1985.
2. ibid.
3. The pain drawing is an outline drawing of a human form on which patients are encouraged to shade or mark their pain. This can be both anatomical and qualitative with different shading to represent the nature of the pain (or pains) and its site and radiation.
4. Barthes R. *Camera Lucida*. London: Vintage 1993.
5. Sontag S. *On Photography*. London: Penguin 1979.
6. Dwoskin S. Interview 2001.
7. Spence J. *Putting myself in the picture*. Seattle: The Real Comet Press 1988.
 Spence J. et al. *Time and Light*. UK Film for ILEA, TALP 1987.
8. Richardson R. *A Necessary Inhumanity? The role of detachment in medical practice*. In: Kirklin D and Richardson R. (eds) Medical Humanities. London: Royal College of Physicians. London 2001, 109-22.
9. Foucault M. The Birth of the Clinic. London: Routledge 1989.
10. Wall P. Pain & Able. Ed Dykes N. No 11 June 2000.
 Wall P. Pain, *The Science of Suffering*. London: Weidenfeld & Nicholson 1999.
11. Dwoskin S. Interview 2000.

Perceptions of Pain

At times I have found it impossible to describe my pain, particularly to doctors, so when Deborah explained the project to me and asked if I wanted to participate, it seemed an exciting and important undertaking. When I was well, I worked as an administrator for a design studio where it became apparent to me how effective images could be in communicating ideas, emotions and feelings.

To help deal with the pain and control it, I tried to perceive it as a tangible thing, I had to be able to describe it.

I have had pain for over 25 years. Some people refer to their chronic pain as 'it' as though it has become part of them, but for me it is almost an alien body. When I was about 6 or 7, I used to swallow chewing gum and my mum used to say it would go down into my body and get stuck. I can hear her saying it now, and it makes me laugh. But sometimes that's how it feels, like a huge piece of chewing gum that I've swallowed and it's become tangled around my spine.

Sometimes it's a metallic pain. I don't know if it's connected to the fact that I have metal implants following my operations. They are embedded into my spine and although logic tells me I shouldn't be able to feel them, when I'm lying on my back doing exercises, I feel I can.

At its worst it feels like rusty, hot barbed wire. There is almost a taste of iron. It goes from my heel up my leg and into my back – a throbbing length of hot barbed wire. It is wound round itself, twisted up with hot sharp points like the red hot part of blown glass.

Linda Sinfield

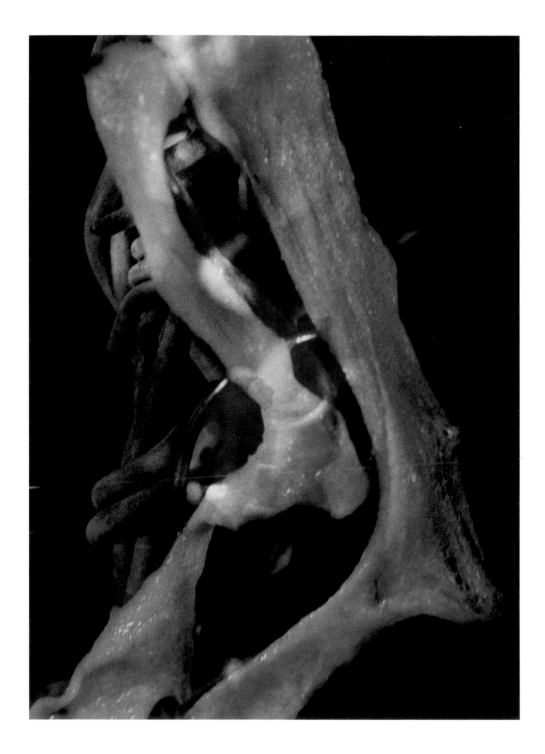

I think some of the other images I have for my pain are to do with fear and with being out of control. During bad times I often dream about a huge black rat. I have an extreme phobia of rats and it is as though in my dream this creature personifies my pain.

We are all affected by pain at different times in our lives. However, chronic pain sufferers have, for a long time, needed a means to communicate exactly how their pain feels, not only to the medical profession but equally to family and friends.

It is also helpful to have an alternative way to relate to the pain ourselves. When I first saw the images that Deborah and I produced together I felt a shiver of recognition mixed with feelings of anger and sadness. But for the first time I was able to point at something and say 'that's my pain'.

I hope these images will help others who experience chronic pain in describing what they feel and convincing sceptics that their pain is real. This is most important at times of crisis because that is when it is most difficult to express yourself.

Linda Sinfield

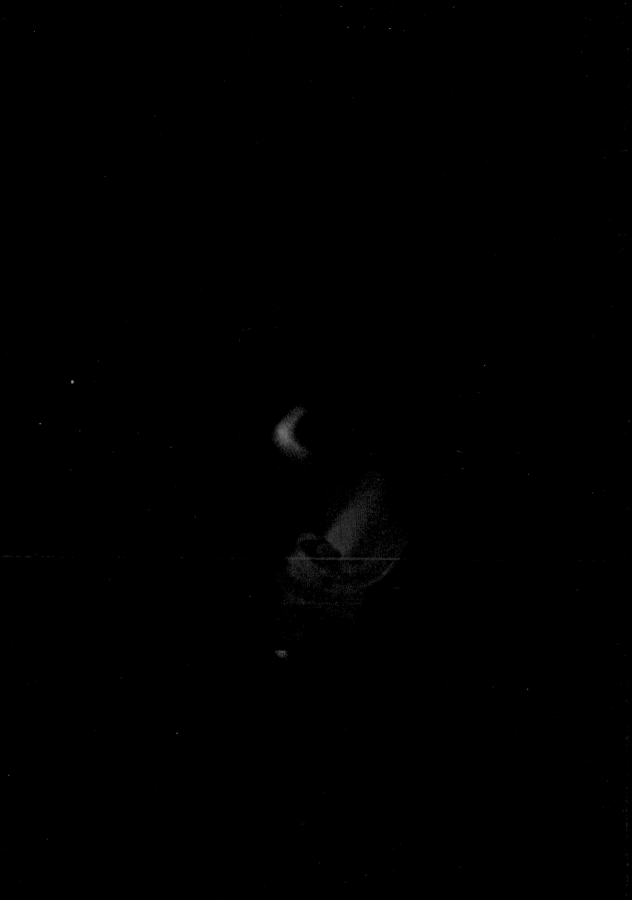

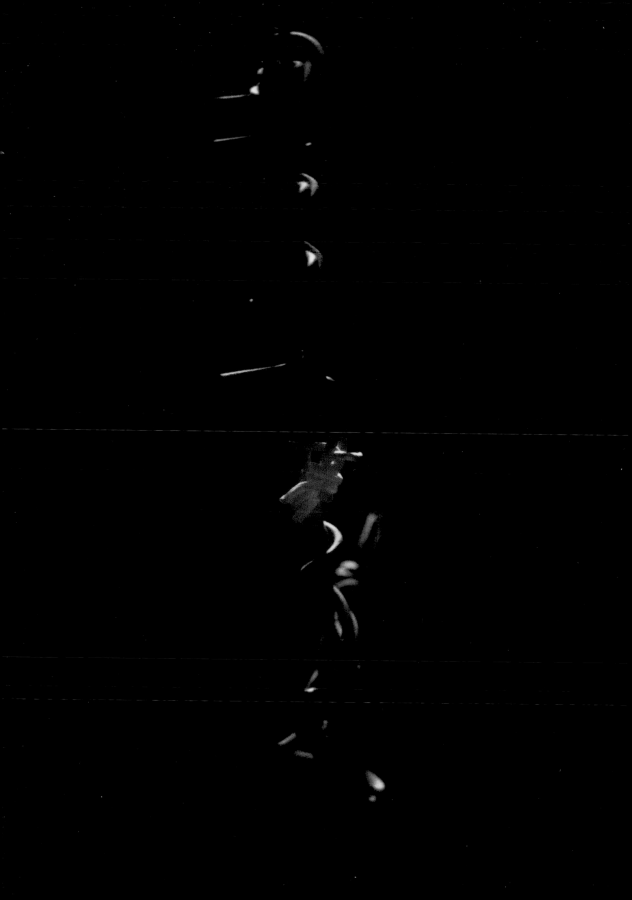

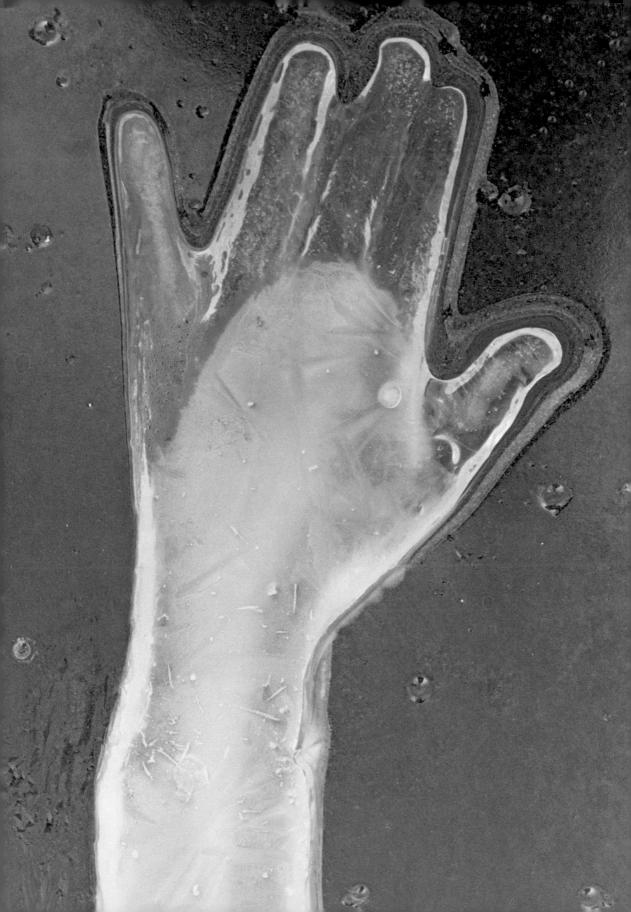

These images arose initially out of my own work dealing with loss of identity as a result of pain.

Although for me their source was psychological in origin, they appear to reflect physical qualities of other people's pain, so I have included them here. Many sufferers have described their pain to me in terms of temperature, ranging from 'burning hot barbed wire' to 'the white pain is like ice' and 'I get very cold legs, I have a piece here like ice.'

One sufferer wrote: *The feeling began in my feet. I awoke to a feeling of intense cold growing through my feet. It felt as if my veins had turned to ice – and were pushing freezing water around my body... Thankfully the sensation did not get any further than my ankles... I was afraid that my whole body might become frozen – that I would turn into a block of ice.*

The photographs were made by the sea as they melted in the sun and dissolved back into water. For me they are an attempt to experience loss of what is 'known', not as absence but as a chance for change and transformation – an acceptance of the state of 'unknowing' and 'impermanence' as part of a continuum we are all part of.

Deborah Padfield

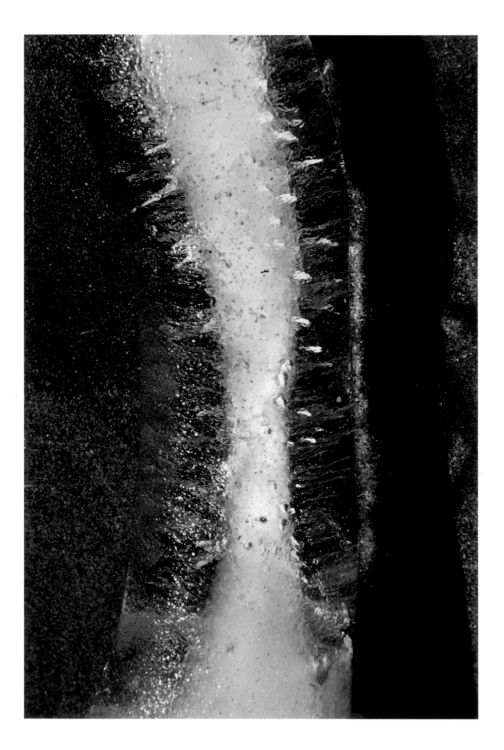

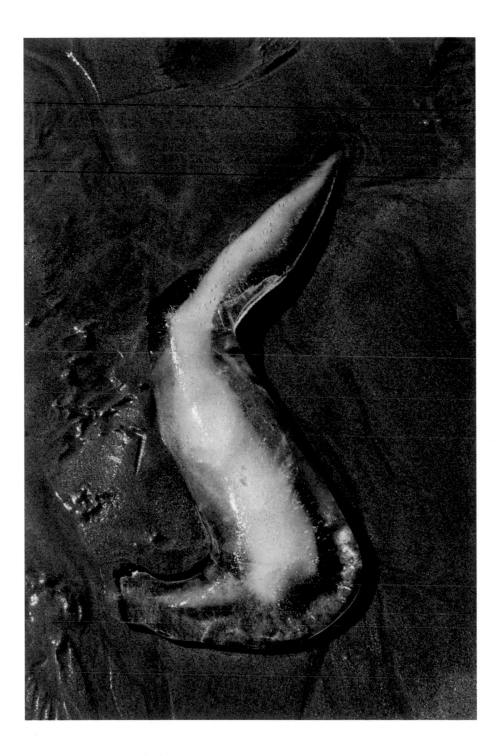

The idea I had was to photograph the scars on my arm. I had people not believing me and so I became very depressed and self harmed. I have scarred arms – for me that is an important part of this whole process, because that is what the pain made me do. It says to me that is how I expressed my pain. It was the only way I could express it at the time. In order to make scars like that you have to concentrate quite hard so it takes away from the pain that is there all the time. I want to show my scars because I know that there must be other people with pain who have felt as desperate as I have. If I stand up and say I have done that it gives other people a chance to say, 'actually I have felt the same way'. It removes the stigma and the need to cover it up.

Helen Lowe

I feel like I'm some kind of alien, I
ask for help and people don't believe
that there's anything wrong with me.
If I need help I have to explain why
and what's wrong with me before they
will try and help me.
The pain is invisible,
people think I'm
making it up. Even
doctors told me
that I didn't look
like I was in pain.
What am I supposed
to look like? I feel like
going round with a
placcard explaining what
the problem is, so I don't
have to tell people all
the time. The scars on my
arm, though, are very visible.
I can't hide them any more
and people stare. Most don't
ask me about them, except
the children I meet. What do I tell them?

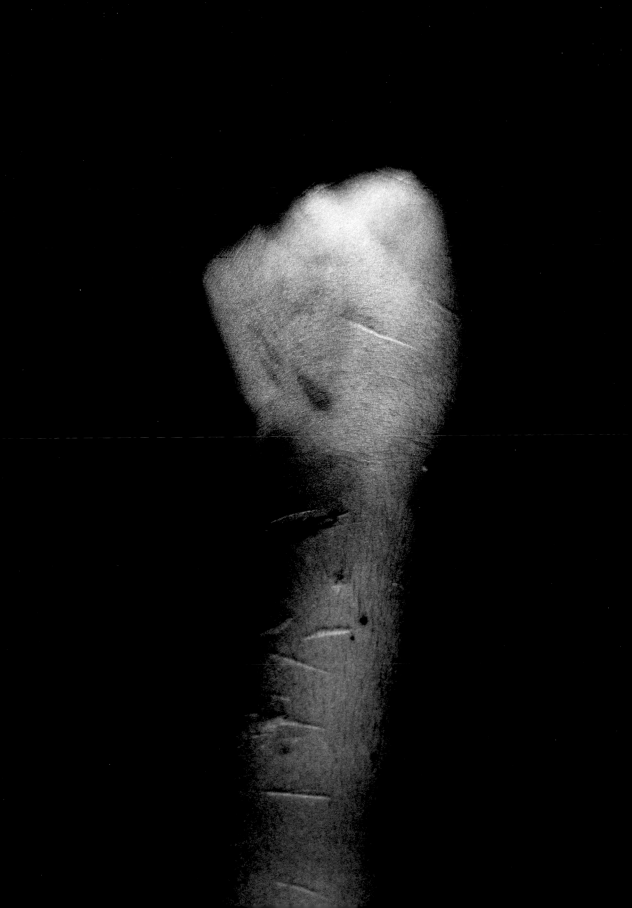

I am 65 years old and I have had pain for a long time. I have a wealth of experience. I have always been inquisitive and interested and have enjoyed taking part in this project and being able to use my imagination to the full.

Pain is such a difficult thing to explain. I think I have gained some understanding of pain through being at INPUT and taking part in the project. There is a future now and a chance of doing bigger and better things. The most difficult part for me was bringing the pictures to fruition. I could not imagine at first what the pictures would come out like.

Pain is a flash. The missing link. If you take the skeletal away or the body away, all you are left with is the brain and the nervous system. The missing connection, when the nerve that comes down to block out the pain is broken and is no longer there. When mine first happened it was as if somebody had put a knife in my back. The spine is not soft, it is like metal. It would hurt the metal wouldn't it if you got two lots of metal. When they cut the nerves, which didn't cut the link properly, that would give me a lot more pain. There are flashes when it is broken at the edge of the chain.

John Pates

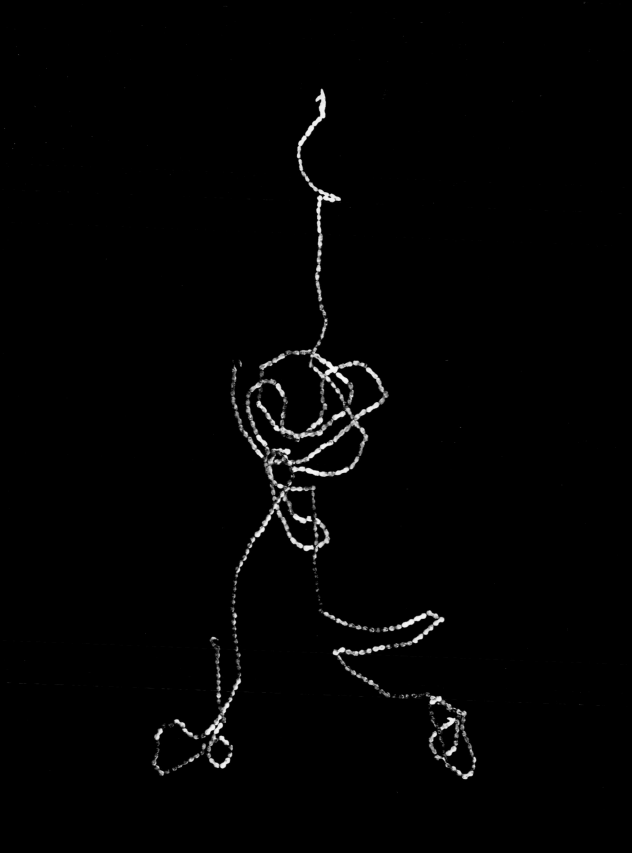

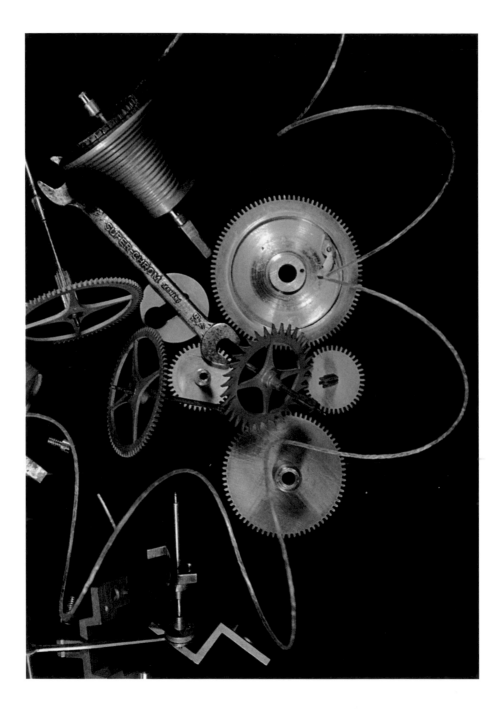

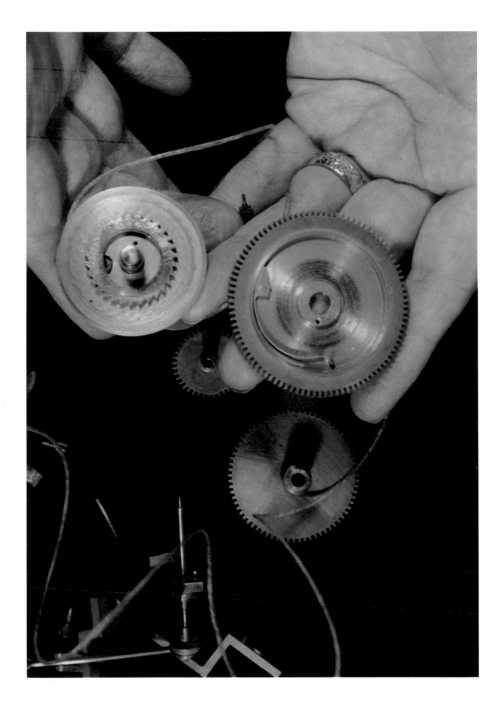

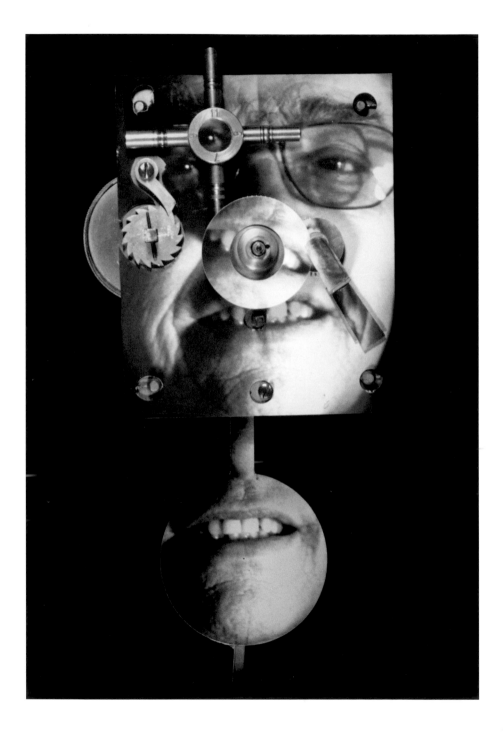

Pain turns everything on its head. When I became ill, I had to sell everything in the house. I had no money. I had been a postal sorter on the night mail. Day and night are out of sync. It is an interesting situation. You are living in different time scales. Time-keeping was very much part of my life. It is in me here. I have to be everywhere just before time, I mustn't ever be late, since I was in the army and on the railways. It comes into your system and it never leaves.

When I was injured, I couldn't move at all. I was wearing a watch, so I started taking apart all the tiny pieces and putting it back together again. It has taken over my life now, horology. It is my hobby. I couldn't move from here to here, so I started off taking pictures of the clock's movements. I taught myself. I took it apart again and again. You can't dismantle the body like a clock. As we have been talking, I have been thinking that the clock is quite interesting. You have a suspension spring on a clock and if that breaks it will never work until you replace it and it is a very small item. If you think about it, the vertebrae are very small items, like a chain and if the chain breaks you have to repair it. The power source of the clock is a coiled spring. The power source in us is the heart. These clocks don't die sudden deaths like the quartz ones. It is a concept you can look at in many different ways.

Unfortunately it is not just pain. I have so many other medical conditions, I am a greedy bugger really! I have been revived from death. There it is, you have to grab it, as you never know when the next one is going to come along.

I am giving something back for what I have been given – life basically!

John Pates

I have been a chronic pain sufferer for over 10 years. I am 36 years old, married and have two children. Until my pain started I was a keen sportsman and worked long days as a carpenter/shopfitter. My pain started from an operation that went wrong in January 1992. I have not worked or played competitive sport since. To say it changes your life is an understatement. To make family and friends understand is even harder when you look physically fine.

The idea of using pictures to help explain how chronic pain feels and has affected me over the years appealed because I have found it extremely hard to make doctors understand the extent of my pain. If anyone could see my pain it would be a lot easier for people to understand and accept. Sometimes I think a person with a viewable disability is understood and treated better than people with chronic pain.

I hope this sequence of photographs explains how my chronic pain affects different parts of my body and how it feels. It affects my sympathectomy nerves and the pain generates around my right kidney area. It starts with a solid pain but as it generates it feels like an animal pawing away inside me and tearing away the flesh from the inside out. Next the mass of pain does not move, but as more of my nerves start to get stimulated my wrists and hands puff up and I get a prickly heat, pins and needles sensation. It feels like ants crawling all over and underneath my skin but there is no way I can scratch, push or wipe them off until the cycle of pain passes. At this stage my facial expressions change with my cheeks and eyes puffing up and it feels like it's going to burst my skin open and release all the pressure.

Rob Lomax

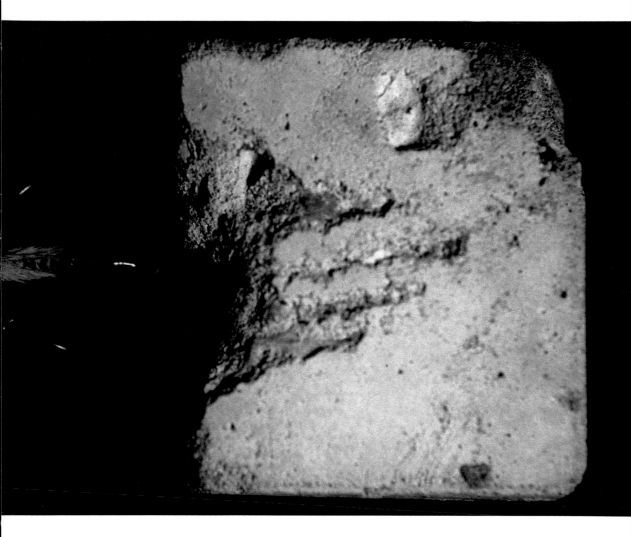

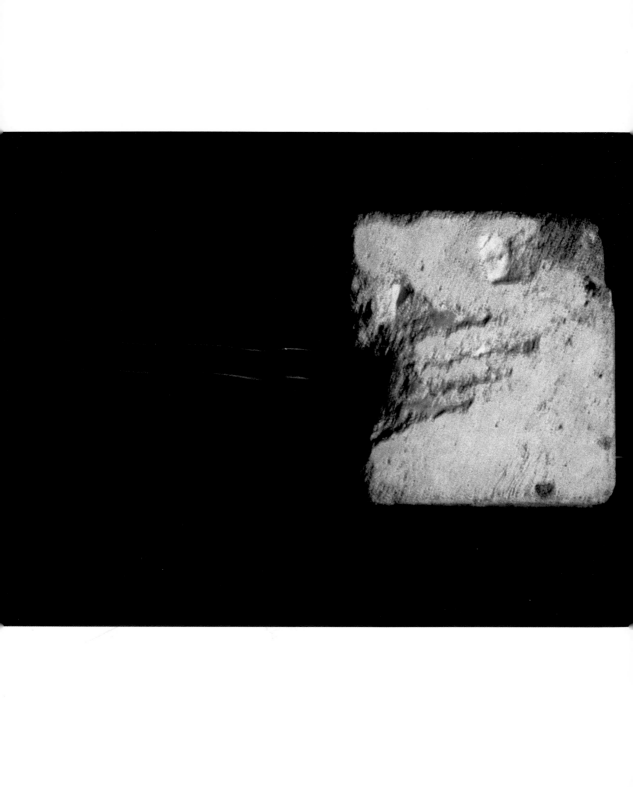

When I get into the zone of pure chronic pain, all I want to do is to curl up and disappear. I feel like I am suspended, in freefall and in a dark place, not knowing when it is going to pass or how long it will last. You just want to be alone in your own little space, not letting anyone in or yourself out. Sooner or later the darkness lightens and you come out the other side with huge relief, but you know it's going to hit you again, but you have no idea where or when.

The pain is like an evil. When you have pain you are stuck in a dark cocoon and you suffer in your own darkness. Pain = Evil; Evil = Darkness; Darkness = Pain.

Dealing with chronic pain is hard enough in itself. It doesn't however only affect me. It can affect everyone who is in my life, especially the ones that are closest. The pain generates through different levels which affect my mood swings and temper. You always tend to hurt those closest to you. I found this project not only interesting but very helpful. Trying to explain my chronic pain, and how it feels and affects me to family, friends and doctors is extremely hard. With these pictures everyone's imagination can hopefully realise the extremeties of your pain. Hopefully it will also help people understand my thoughts and feelings. As the saying goes: A PICTURE IS WORTH A THOUSAND WORDS.

Rob Lomax

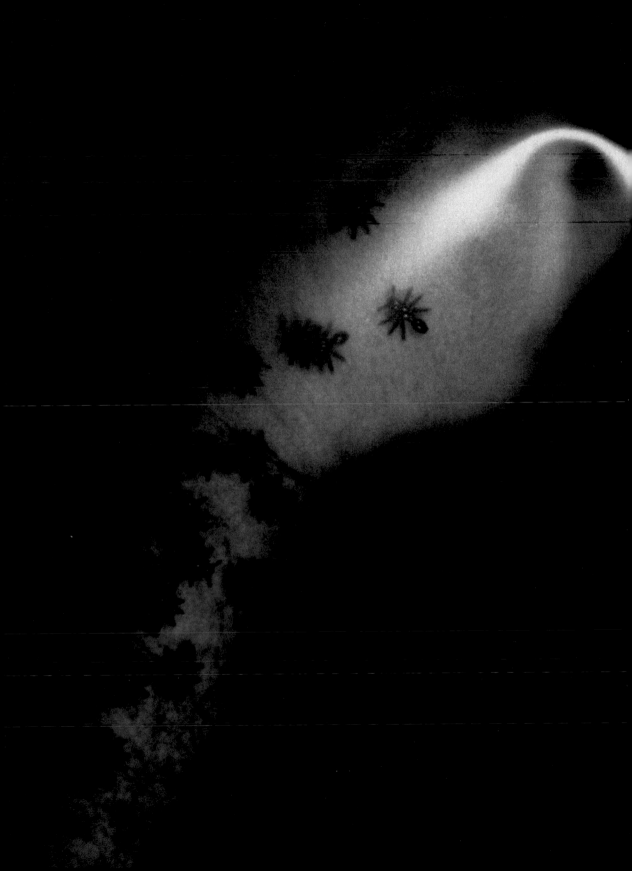

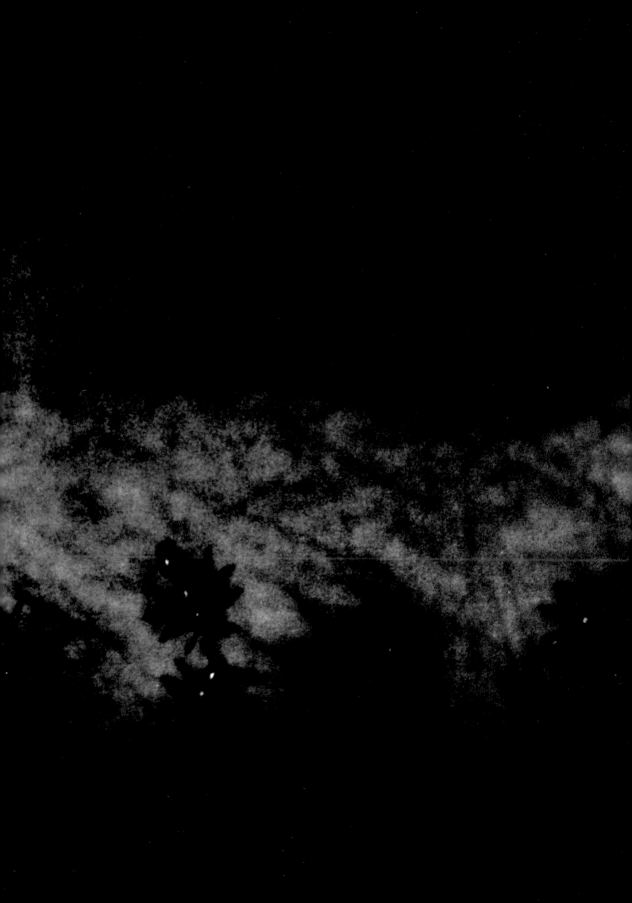

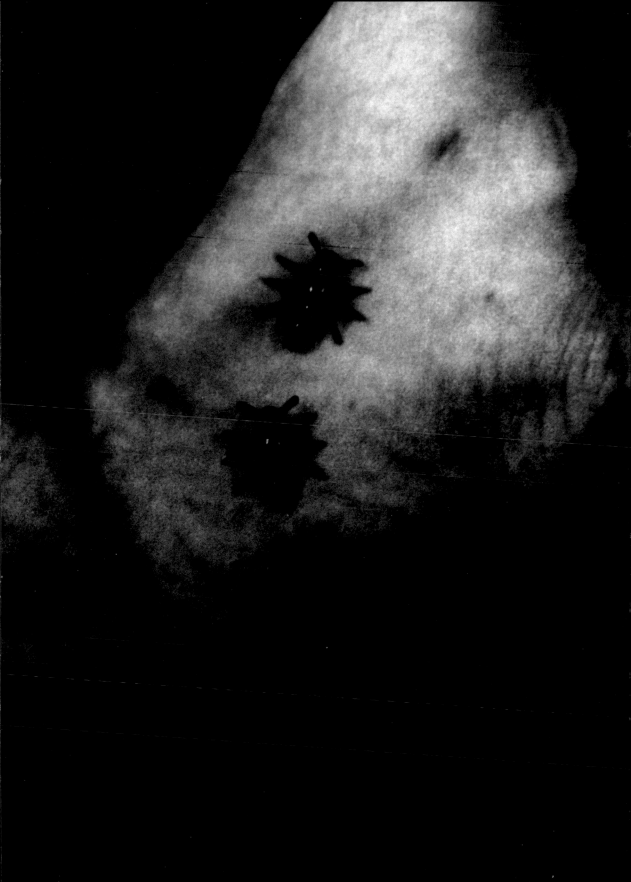

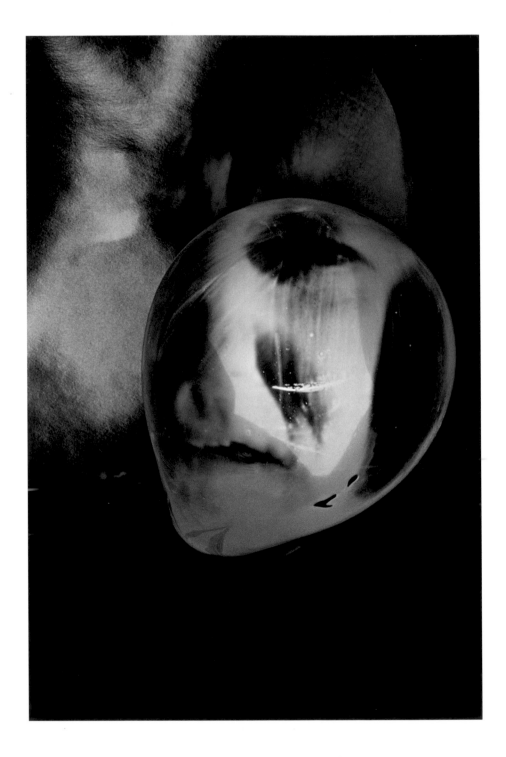

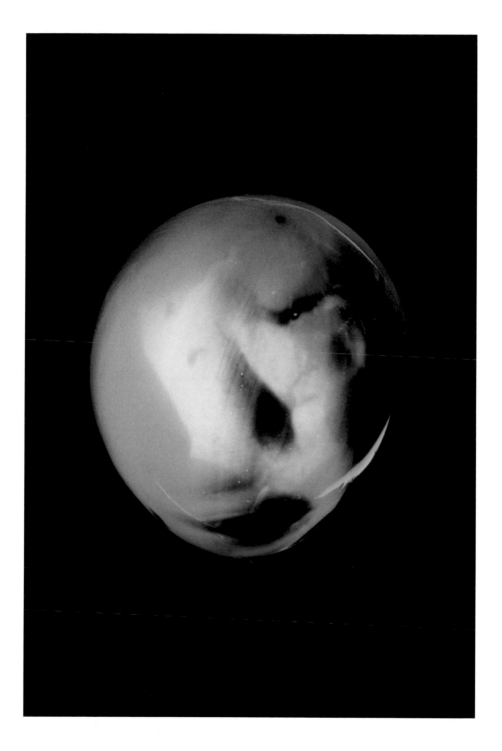

I have had pain for 42 years. I don't think anything is going to help me, but it is worth a try. I have tried not to visualise the pain in the past, but I think it might be good for me to try. I used to paint a lot. I hope to get back to it.

A lot of people have asked me what the pain is like. Most of the time my pain is at an intense pitch. Some people say they have good days and bad days. I don't have any good days. It wears me out sometimes. I feel like throwing myself in a corner. It is absolutely constant.

There are two pains: the mental pain and the physical pain.

I am constantly battling with the physical pain. You could possibly describe it as swords on fire. It is as if they are ripping down my leg all the time. Red hot swords. They move. They start in my back and move downwards relentlessly, like an escalator. The swords on the photographs show that the pain is all over and the herring bone stitch shows that it goes all around the leg. If I could get my hand in, I could lift it out. I could rip it out it is so specific. I think it is probably one rod and a million swords.

Apart from the physical swords and things, is that there are always two of me. There is the me who is talking to you now, but there is another me, all around, rather like an aura. That is the pain and that is what I'm continually fighting to get out of. It would be interesting to see what a person who deals with auras and things like that would make of it. It is a colour. Bright red. It is all around me, surrounding my body and stops at my feet. It is very funny really, because my mind is doing two things at once. I may go out of here and not remember a word you and I have said to each other. While I am talking to you I can react and on top of that I am also fighting the other part of my mind. It is telling me possibly to scream with pain, but I think if I did that, I would never stop. That part of me is bigger than the me that reacts and talks to people and occasionally shouts at people and all that sort of thing.

I think possibly I am battling with my own mind.

During the day I think I win, but during the night this other thing wins. It is another version of me. It is red, but not solid, more like a child's colouring. Some bits are light and some solid, the solid bits are the worst.

I see the torn shreds of material as hope that some day in the future I will step out of this.

Frances Tenbeth

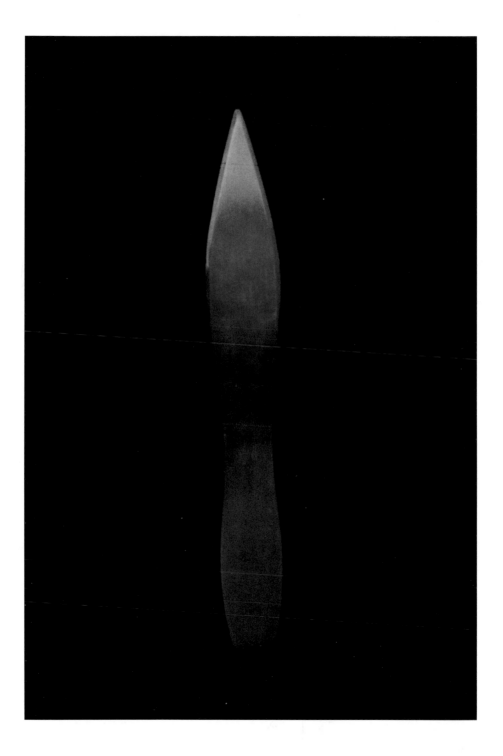

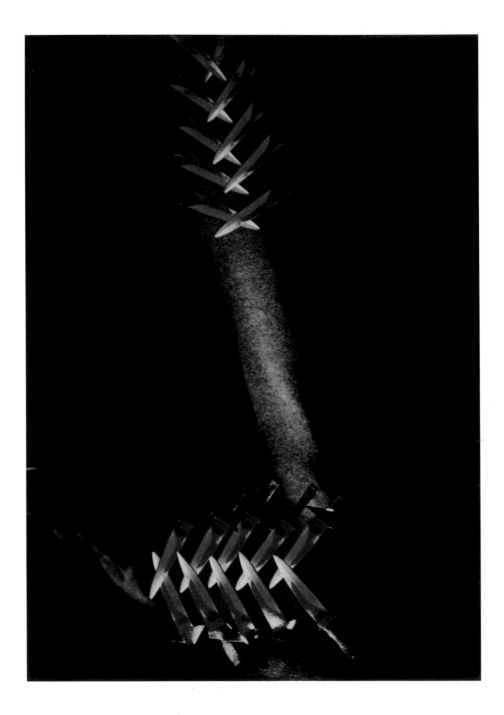

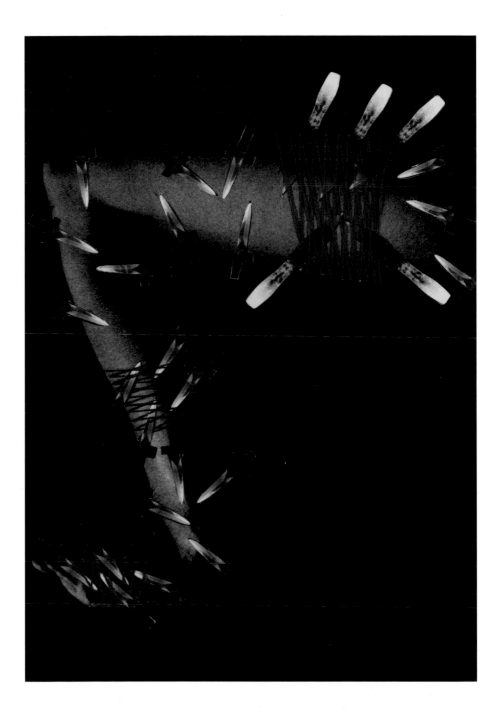

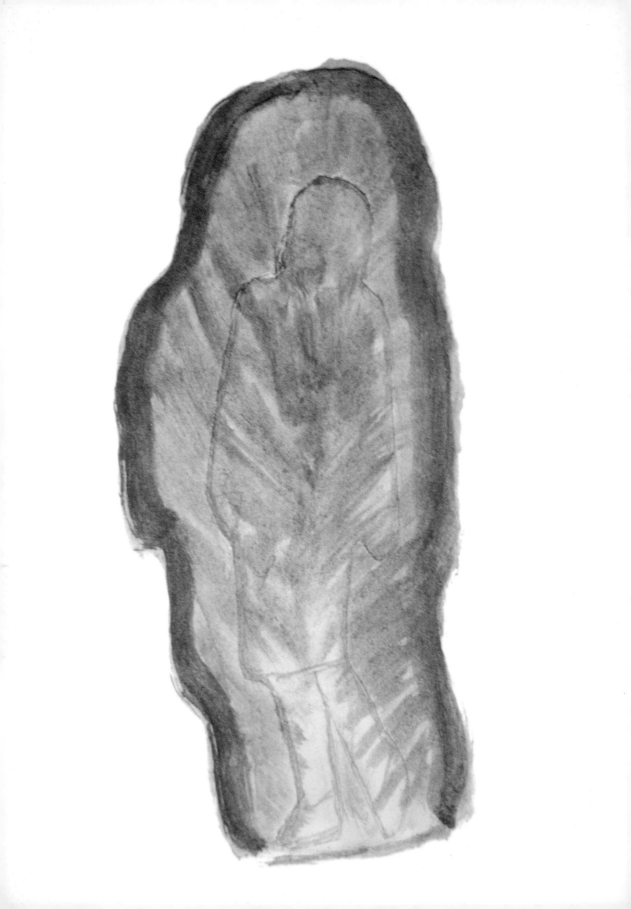

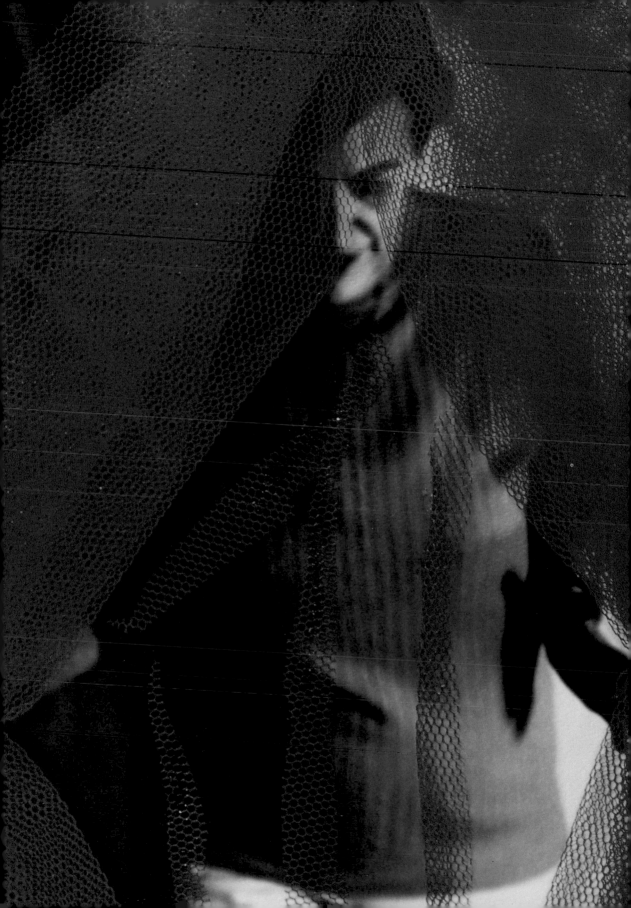

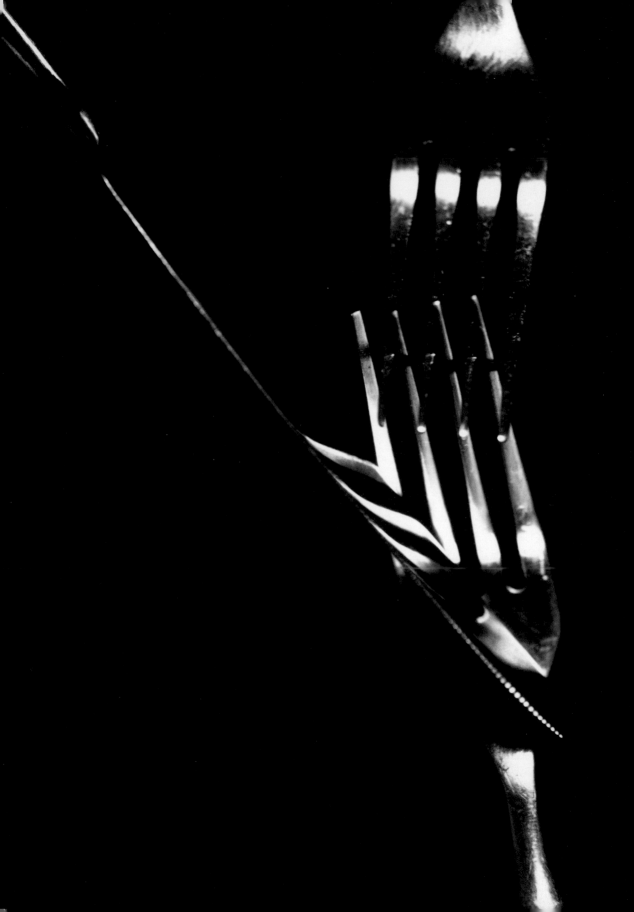

Another image I had was of a jubilee clip. You have the impression of being squeezed. With imagination, I would use the bolt as the spine part where it is injured and use the tube that goes round the spine and just gradually tighten it up like the pain increasing.

John Pates

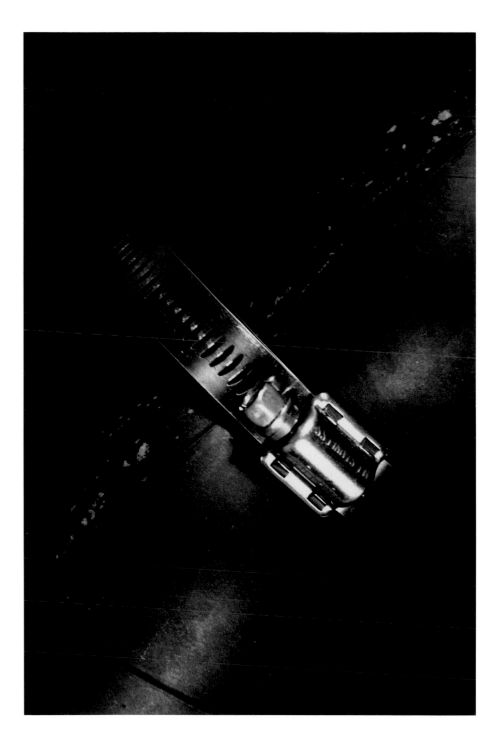

My pain started 11 years ago. Because of it, I feel unable to help in the business in the way I would like to. My wife has had to take over. I feel awful about that. I am a perfectionist. I have often built up very high hopes and been let down. I try this treatment and then that, and each time, I hope and get very enthusiastic, and then I get very disappointed and feel let down when yet again it doesn't work.

The pain is like a red hot wire being pulled around the joints. It is usually the wrists and the ankles. It is very sharp and very intense, coming from nowhere and luckily not very long term. Originally in the first few weeks of pain I would have it very intensely somewhere for a minute or so and then it would be somewhere else, a shooting pain in the wrist and then it would leap somewhere else, for example the shoulder. I have no idea why those intense pains happen. Maybe it's nerve endings or neurones firing off. It is red hot.

The other pain I have, is we have been moving around doing exercises here and the pain is building up all over. I visualise it is as a bath filling up and filling up and then it overflows. In the bath, instead of being water, is your pain and your pain threshold. It reaches a point where eventually it flows over the top and all this stuff goes everywhere. At that point my consciousness switches off. I can cope up until then, but then I have to lie down as it just takes over. Everything stops until I can start picking up the pieces again.

The overflow thing is 'me' totally. It is not just my body that is overwhelmed, but it my consciousness. The consciousness instead of being in the bath is on the floor. It is my brain that is actually being swamped, and that is the part that I resent – that I totally lose control of my ability to think rationally.

It is also a dynamic thing. We were talking today about borderlines. You have to stop before you get to a point where you are in real pain. It is a very fine balancing point. One of the things they teach you on this course is that when the pain is very intense, you have gone too far. What you are talking about is that very fine borderline where you still have got some sort of control and you are not out of control. That is where you have to do all the work.

I like the idea of the bath. It is somebody in a container. People usually see it as a 'safe' environment, but what happens if something does go wrong and it is out of your control? People think it is not going to happen to me, but what happens if you are in this situation of chronic pain? Nobody expects it to happen to them. It just happens to ordinary people.

Robert Ziman-Bright

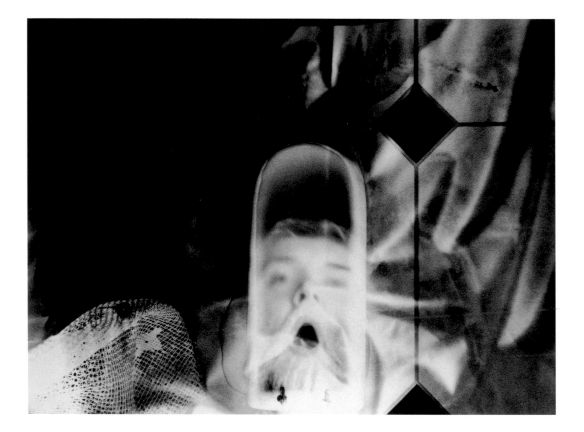

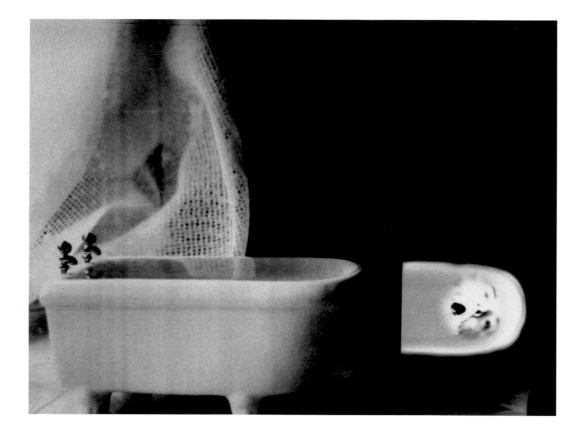

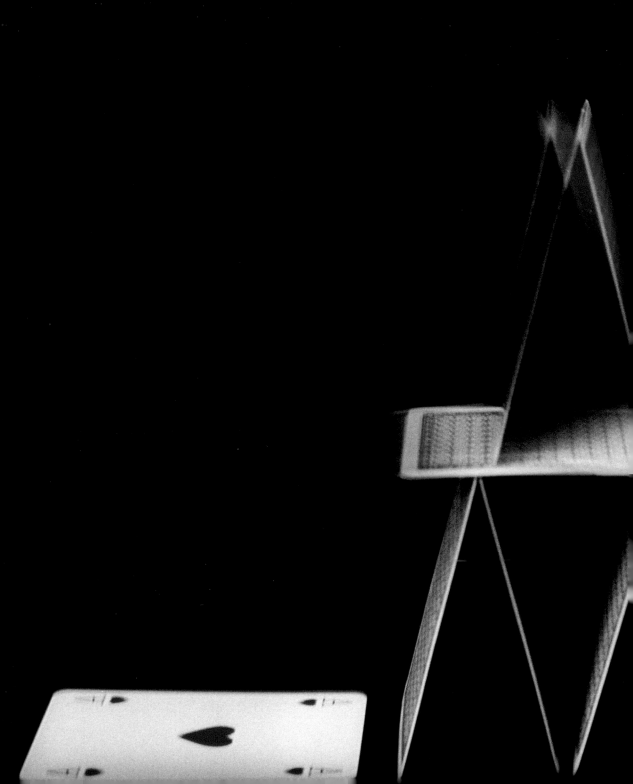

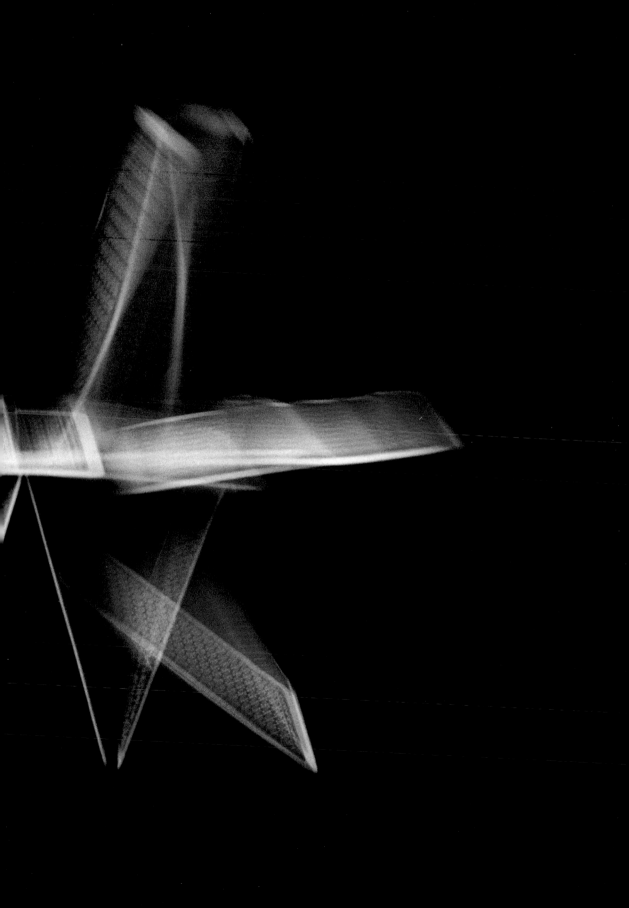

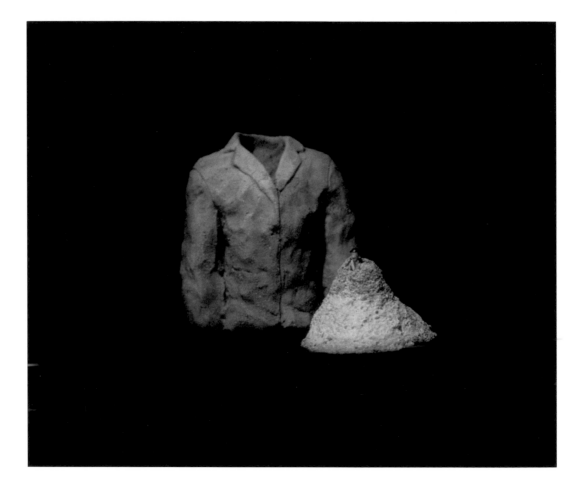

My problem started on 1 April 1995. I used to work in a prison. I was assaulted and fell down some stairs. At that moment I can't remember thinking I had damaged anything because the adrenalin was flowing and nothing registered. Afterwards I realised I had burns on my back and I was in serious pain. I almost could not move. It is like a world within a world in a prison. It is organised confusion. I have had to restrain people countless times over the years, and I always came away with just a few bruises. This time it was different. I was off for five weeks and then returned to work, and slowly the pain was getting worse and worse and I was finding it more and more difficult to move until after a period of nine months I came to a grinding halt. I woke up one day and I just could not move.

It felt like I was in a straight jacket. I couldn't move anything except my head. The position was reversed. In a prison you have to respond very quickly and sometimes have to use physical control to put straightjackets on, and now I couldn't move at all myself. It was as if having been a very active person, suddenly I was in a straightjacket. It was very isolating. I was alone with my pain. I lost all my identity and I did not recognise the person I used to be. I used to know exactly where I was going, I was in control, my whole life was regimented and then suddenly something happens to me and it starts to change and I am in a position where I know nothing. For someone like me that is very frightening.

I did not know where I was. I was trapped in a black isolated space – no one could be in it with me. The nearest material I can think of is 'concrete', because slowly it sets and then you cannot move. That cement suit is me.

Patrick Dixon

The light in that picture means hope, a helping hand, somebody gives you some hope. I walked through the door (INPUT) and I knew as soon as they opened their mouths where they were coming from — that they could help me. So many people don't accept that chronic pain is a real problem. It is like the first world war. The guy suffered from shell shock, but they still shot him because they thought he was a coward, but basically he had just had enough of death and everything else that goes with war. Here they talk a different language. Now I know what to do again, I have the tools, it is in my hands and I am confident that it is going to work for me.

I enjoyed the freedom given in trying to produce my pain in photographs. I was encouraged to tell it how it was. I have tried to be as open as possible. I have changed a lot since this happened to me. In many ways, I am a changed man.

Patrick Dixon

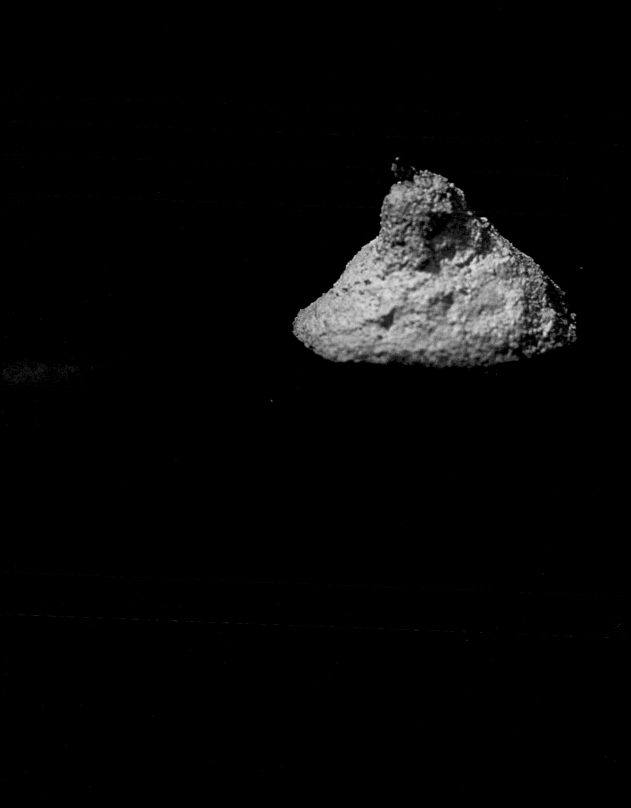

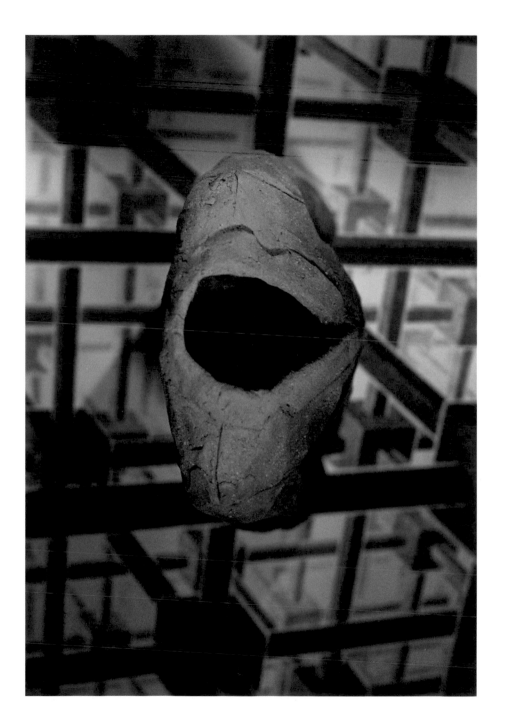

I have been asked to describe my pain in the form of an image. How do I actually see my pain? It is an interesting, but also a very difficult question. The image I came up with is this:

I see a huge rubbish tip that has mounds of rubbish in it. It feels to me that there comes a point in my pain where I feel that things are under control and running along fairly smoothly, when suddenly another load of rubbish is poured onto the site and I am back to square one. It can be other people's rubbish, it can be a change of medication, it can be anything. I can never be truly in control or get the rubbish level and smooth, because always something comes along and makes it mountainous again. It is about absolute chaos and the feeling that people come along once a day or a week and just dump more rubbish on the tip.

I would like to try photographing a pill box where the label doesn't say what you expect it to. We have been thinking about using mirrors so that it can reflect back the unexpected. Pain changes your perspective. It is like where you sit in a room you have a different view. Two people in the room see it the same as everybody else but have a different experience in their mind.

You can't see pain so people don't believe it. I had that even more so with doctors. They would say "you don't look like you are in pain" and many of them did not believe me. I could be crawling around the floor but it would not help. I had one example where a doctor sat there and said "You cannot be in the pain you say you are in." I said, "What do you want me to do to show you I am in pain?"

What do you have to do for people to take you seriously and listen to what you are saying? That was the most amazing thing about INPUT and seeing Dr. Pither. He listened and I thought this is the first place to understand what I am actually going through. I want to show with the photographs what incredible levels you have to go to, to get yourself understood.

I have really enjoyed the hands on stuff – i.e. cutting up photos and screwing up bits of paper and starting to use the camera and learning more about photography in general. I feel that I have had a chance to express how I feel about my pain in a way that I wouldn't have before. I have a visual memory so it has been a great way for me to be able to communicate my experience.

I borrowed a camera and have carried on taking photographs myself. Now I am moving slightly away from photographing pain. I have been looking at unusual perspectives or angles on things and have recently been asked to provide publicity photographs for the opening of a new nursery school.

Rachel Brooks

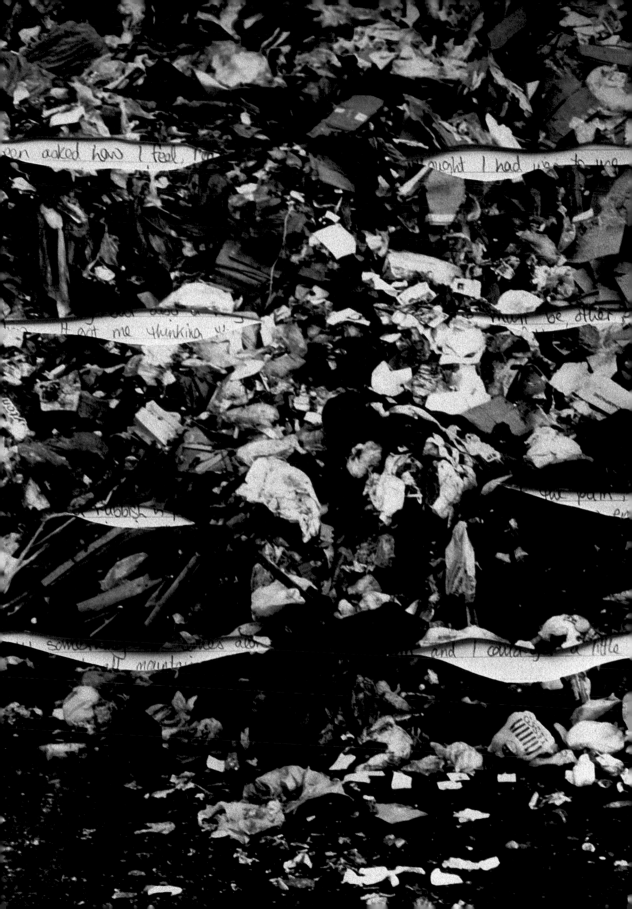

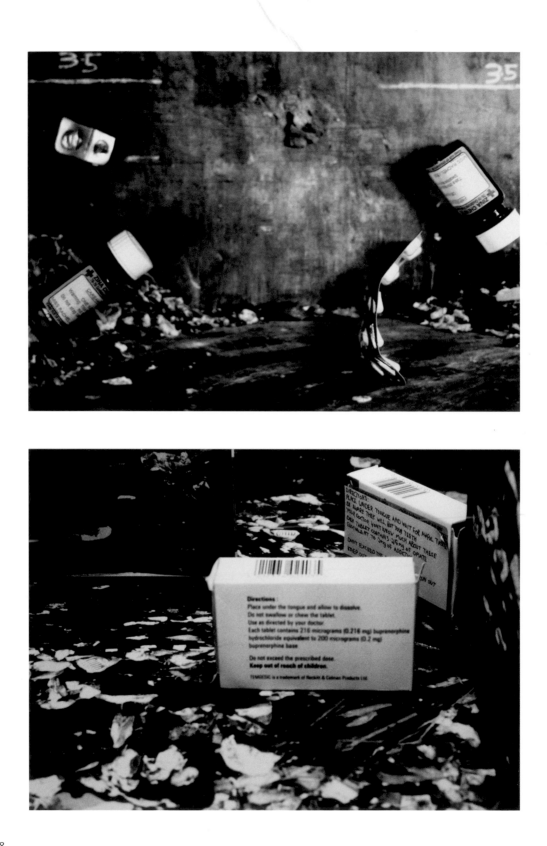

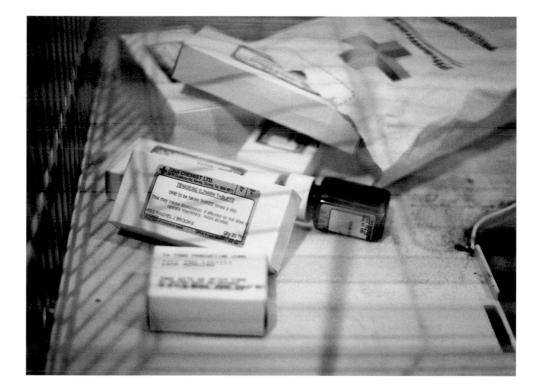

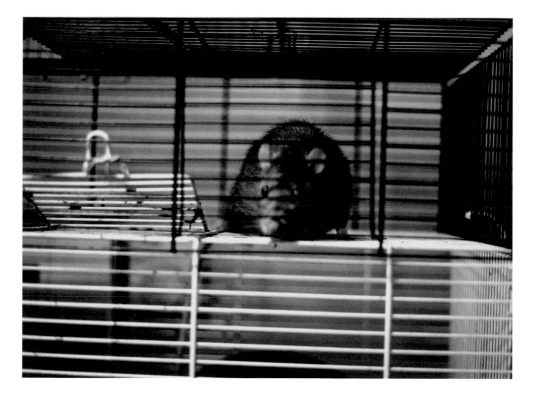

I TRY TO TALK, BUT THEY DON'T
I TRY TO SPEAK, LISTEN,
BUT THEY DON'T BELIEVE,
I TRY TO SCREAM,
BUT I'M "MAKING A FUSS",
I TRY TO BE HONEST,
BUT THEY DON'T NOTICE
 HOW DO I MAKE THEM UNDERSTAND?

I SELF-HARM,
AND THEY TELL ME I'M GOING MAD,
I ATTEMPT SUICIDE,
AND THEY DUMP ME IN HOSPITAL,
I CRY OUT, "PLEASE HELP ME."
AND THEY GIVE ME MEDICATION,
BUT THE PAIN'S STILL THERE
AND STILL THEY WON'T LISTEN,
HOW DO I MAKE THEM UNDERSTAND?

I have had pain for 25 years. There are good days and bad days. Even on a good day I still have pain, but I am able to think about something else. On a bad day or in a flare up, there are times when you come to the edge of it. I have worked my way through the anger and the doctors.

There are different levels of it, different steps up. You have to try to get it in control before it gets control of you. It is gradual, it doesn't happen overnight.

The keyhole is like the spine. Metal is like the nerves. The stone is heavy. It makes you feel cold. On a bad day, it is like being caged up.

Pain is like a barrier. It stops you doing what you want. You can see something, but there is something in the way. When I take a photograph, I don't know what it is, but something just makes me click.

Penny Harding

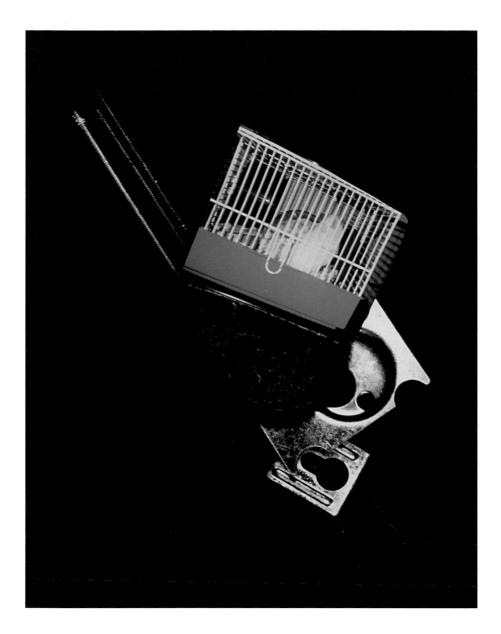

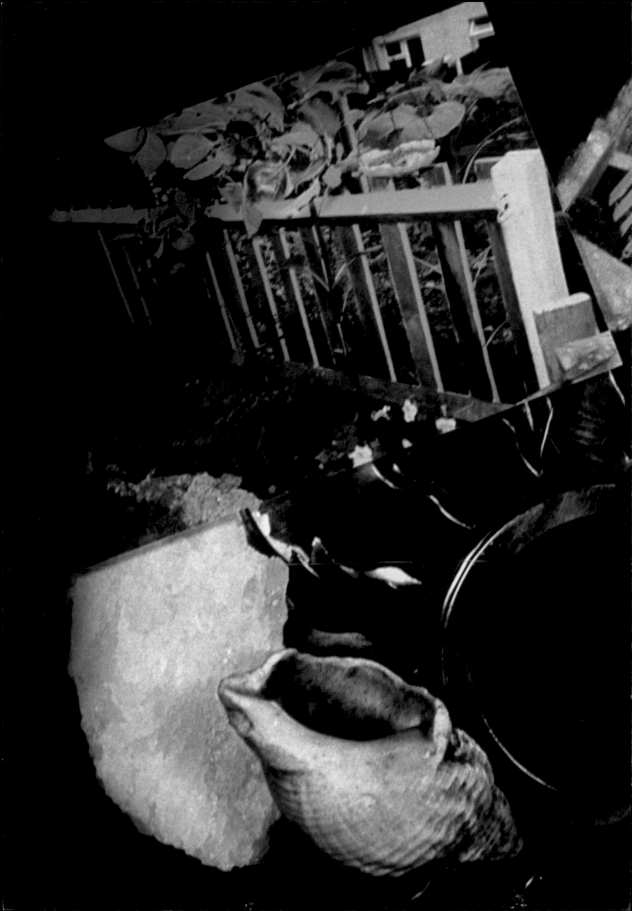

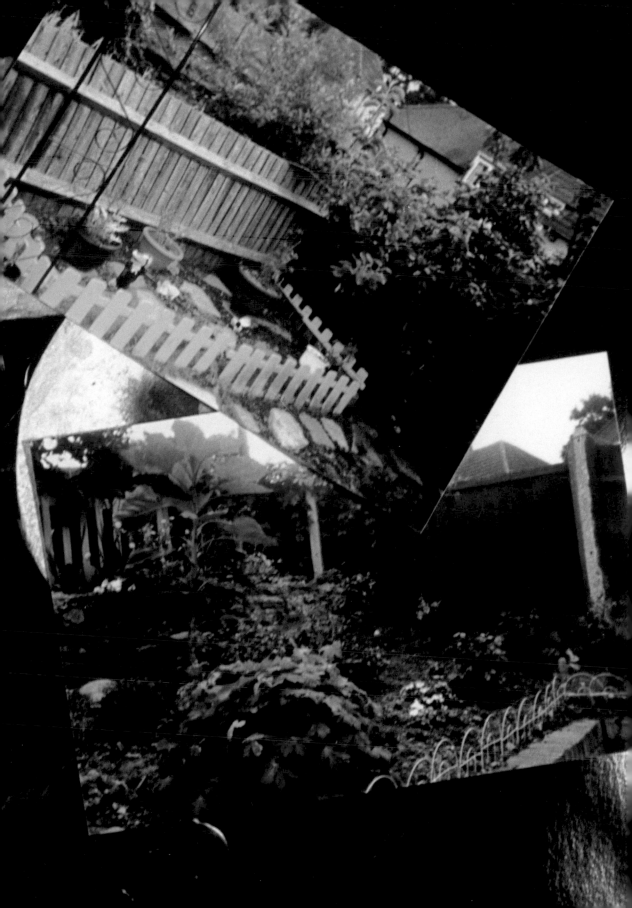

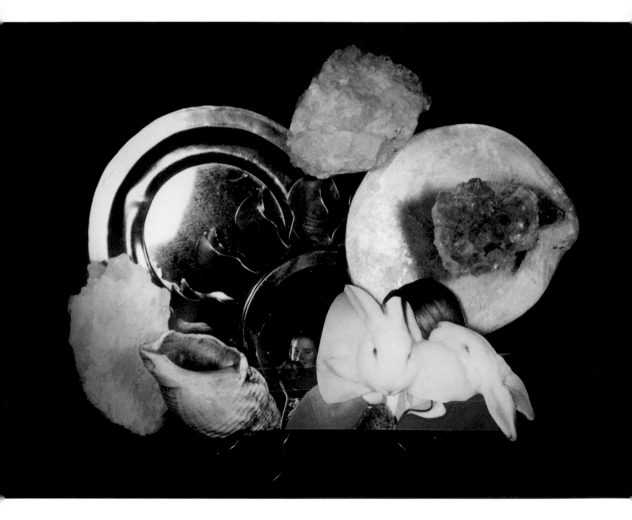

That is Gizmo and Pipsqueak. Those two want to be cuddled. They want to be held, they don't want to be away from each other. They are tired and exhausted. They have mixed emotions. You see there are two ways of looking at the same thing. With the mirror we tried to get someone to be in two different directions at the same time.

I have a twin sister. We are not identical – we were born 23 minutes apart. We are very close. When she went into labour, I felt the pain physically. I feel other things too – it just happens. She doesn't feel my pain.

Penny Harding

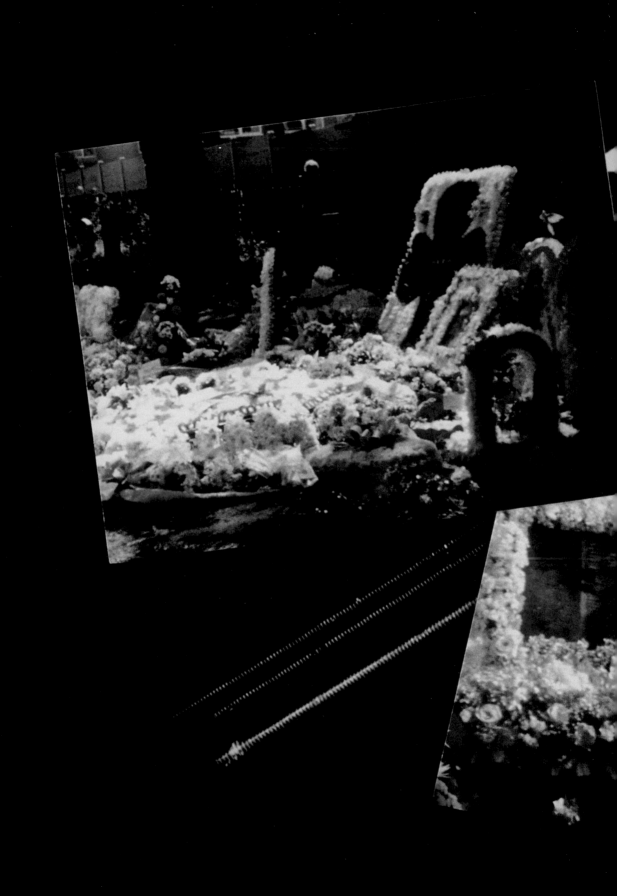

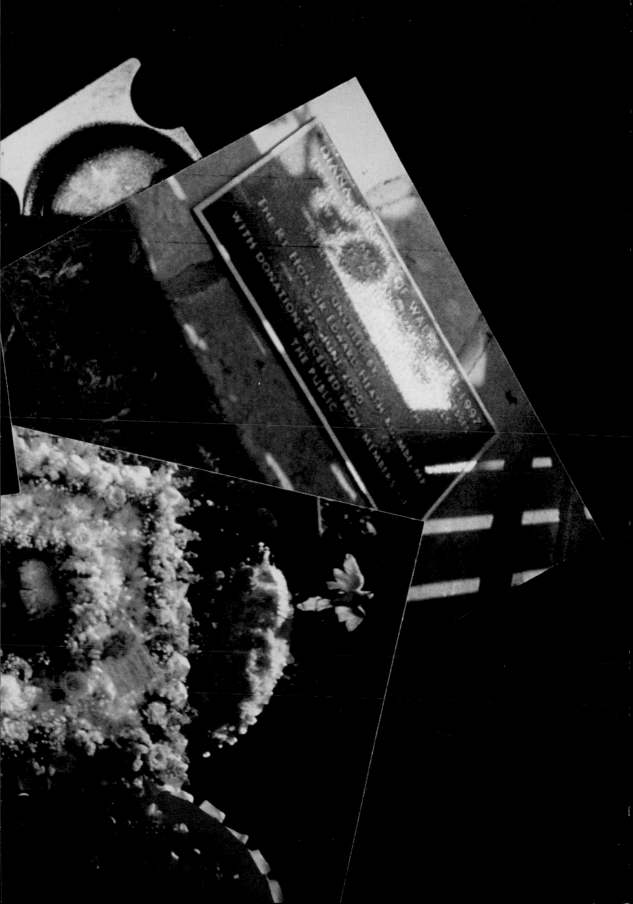

The sunflower made me think of what I'm going through. It is just in agony by the look of it; I caught it on a bad day. I didn't have a very good day that day. The head is down, it just seems as though it has ended its life, but what it will do this year is it will shoot back up again. The roots are strong. It varies with me... this one will come up again.

What I'm on about is, the new plants are old plants coming up.

The good days are like new shoots coming through underneath – a new lease of life.

Penny Harding

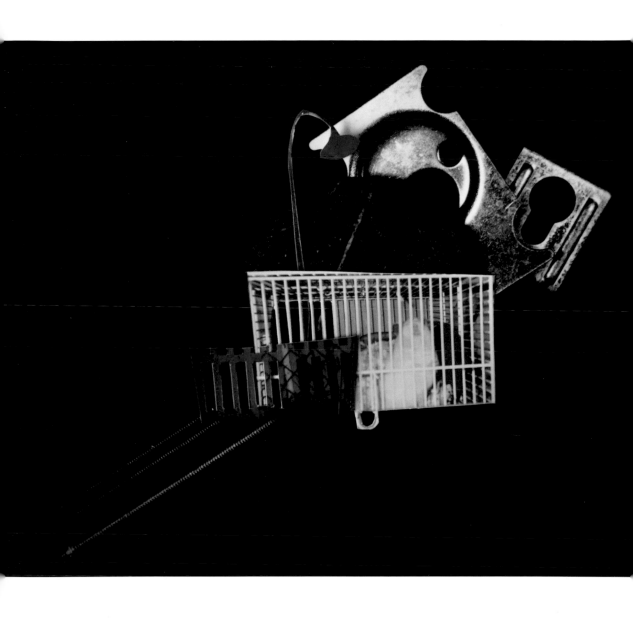

Pain is a concept you can look at in so many different ways. It is like an apple which is rotten from the inside. There is the central core which is the centre of the pain – which is what it would be if it were in the spine – and it comes through and affects the skin. When you have severe pain it increases and increases, so you can imagine that apple going rotten and eventually that would take you up to the peak of the pain. I mentioned facial expressions. When you have someone in terrible pain, such a pain that you cannot move or you dare not and you look at people with that fear on their face, you have got pain haven't you? Look at Salvador Dali's paintings.

John Pates

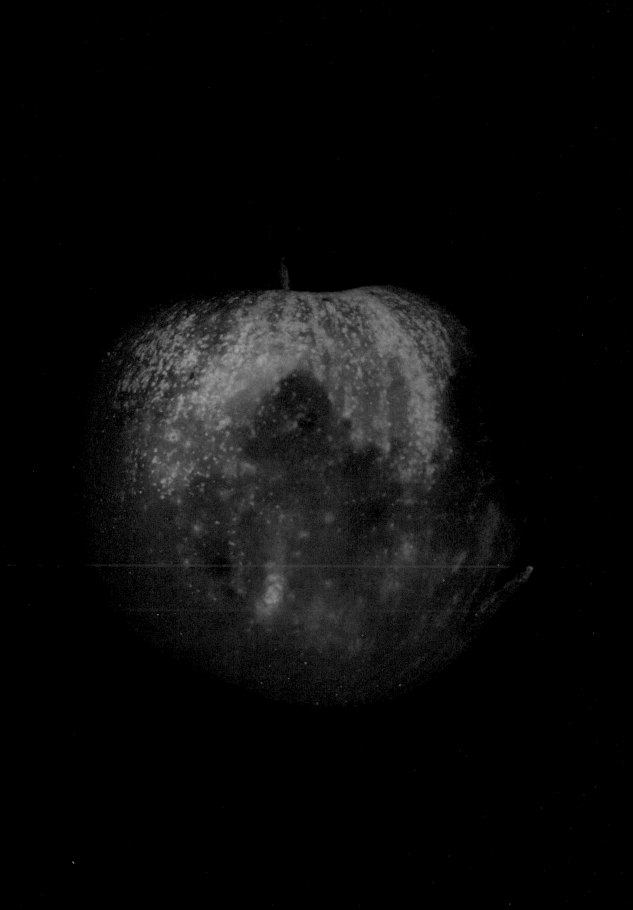

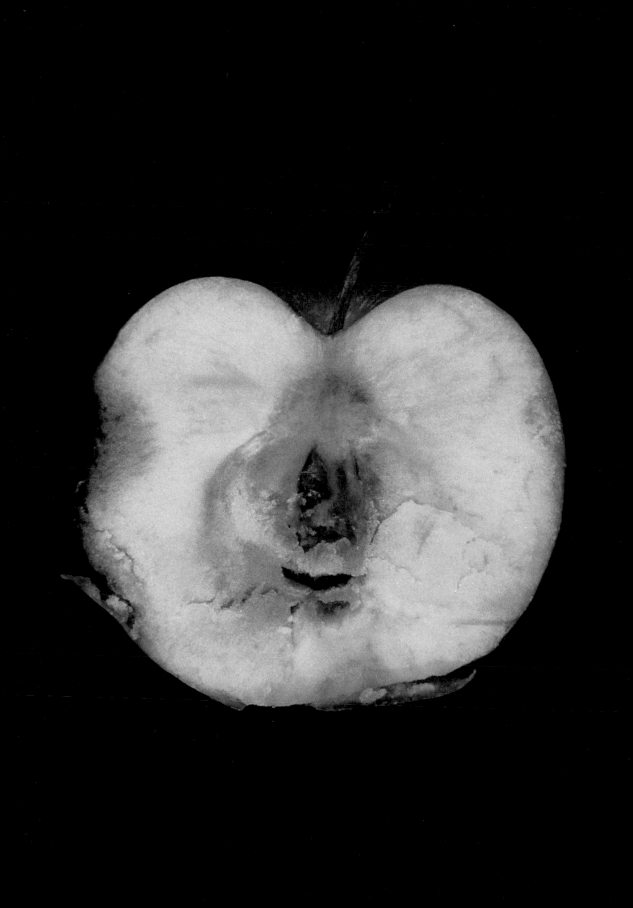

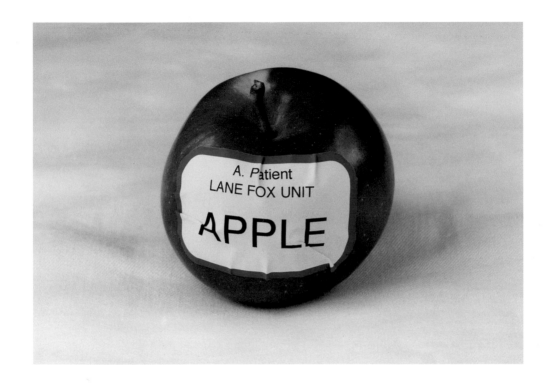

I describe it as a cement mixer because of the density of wet cement. It feels like cement being poured down my throat and filling up my body and I can't stop it. For other people with breathing difficulties like those with cystic fibrosis, they might see it as water filling them up, but for me it is something heavy weighing down on my chest so that I cannot move. Concrete is also a good analogy as it sets, it covers me up, fills me up, and becomes hard as concrete does when it sets. It is probably also to do with having grown up in New York and now living in London and feeling trapped here by not being able to go where I want to or get there because of steps etc. London is not planned for disabled people. It is as though the buildings are closing in, like the density of mixed concrete pouring. The density is not liquid, but solid. Bricks and buildings all around you. Lots of isolated concrete mixers all over the city.

Stephen Dwoskin

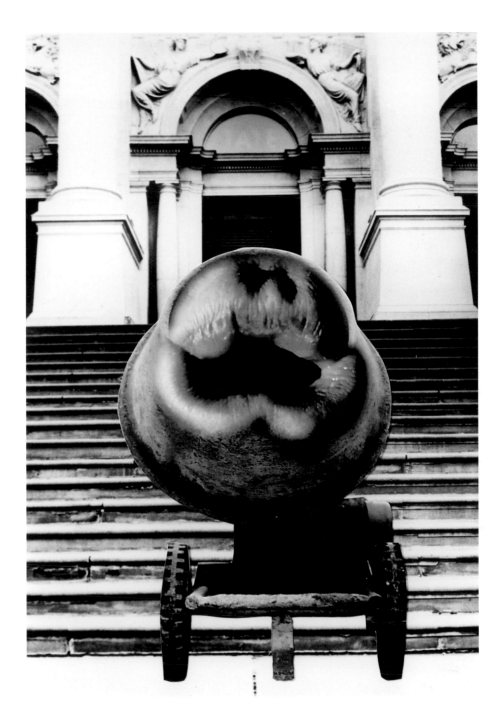

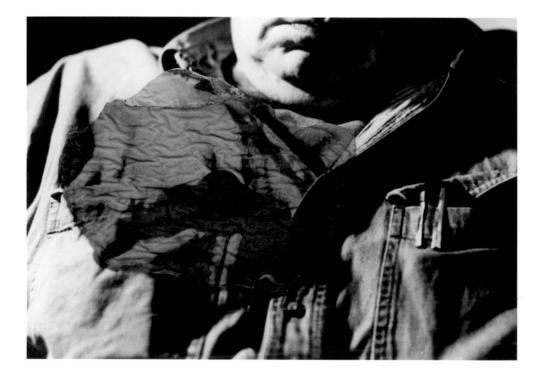

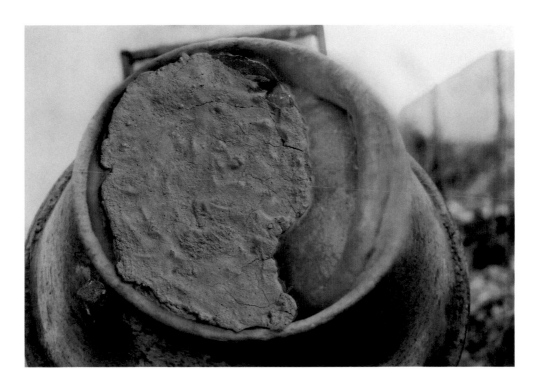

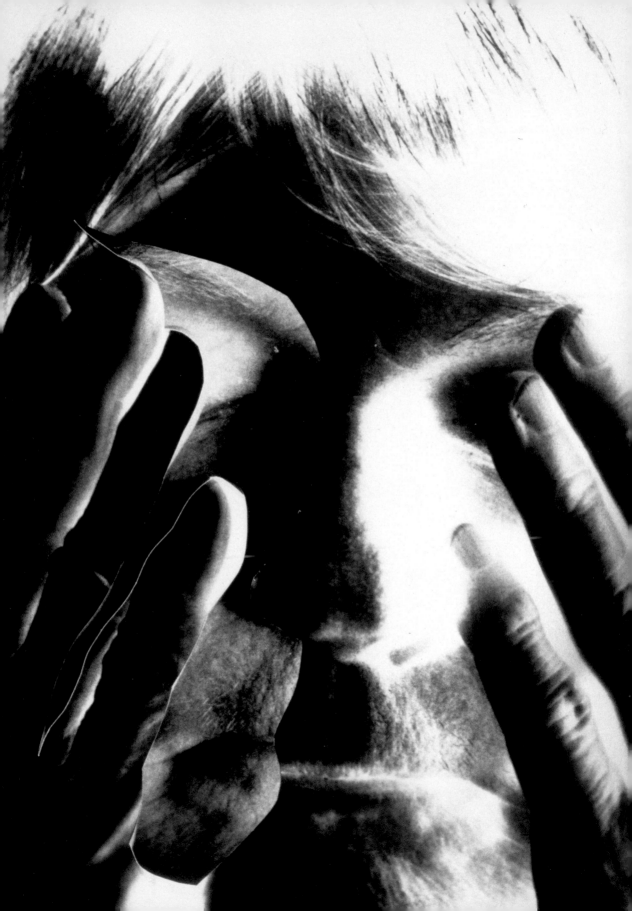

I have a numb patch on my face. It is a strange kind of numbness. It isn't quite as though part of my face were in negative rather than positive, but something like that. It is as though I can't feel the flesh properly, as though it were not alive, as though it had been turned off in some way.

I kept touching it to see if I could feel my fingers.

It's a very distinguishable area, you would have to put a patch on it to show it visually, going out of focus would not be enough. It felt as though it had gone dead, because it lacked all sensation. It's very deep, not just the surface.

It was as though it had turned into cloth or more cotton wool, it had a density and felt more like a blanket. It is about difference. It is not a gap, it is more a difference in feeling – the wrong feeling.

Because it is about a loss, a lack.

Nell Keddie

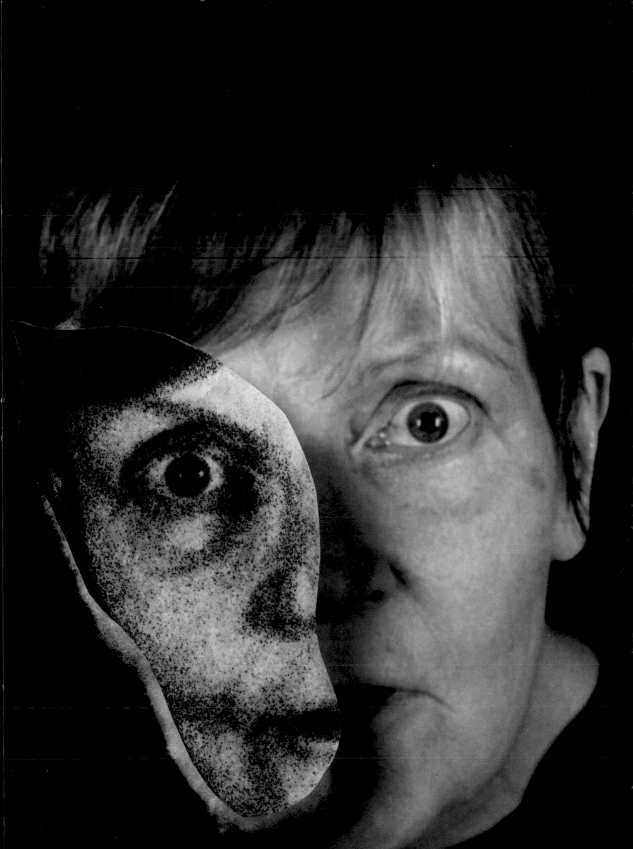

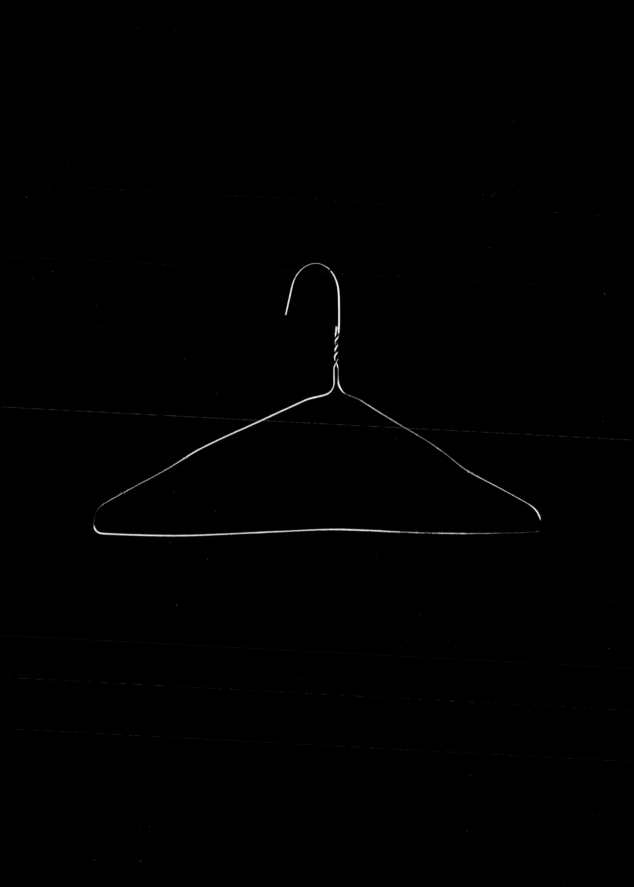

I crushed my spine in the lumbar area. Initially I had low back pain – I didn't feel any of the symptoms I have had since.

I haven't worked out the glass yet. Falling glass – that connects – I haven't worked out how to do it yet. Glass breaks. Fall, fragmentation and repair. I am interested in when glass is fragmented, what you can do with it. Can you pick it up, piece it together again? Leaving it there is terrible.

Glass is very difficult to put back together again.

It was very beautiful. What I think it might echo is that the nervous system in the body is torn, because part of the spine was damaged.

The process of image-making is very interesting. It has made me rethink how I work with glass. When I wake up at night in pain, instead of feeling controlled and overwhelmed by it, I think about how I might represent it visually.

Nell Keddie

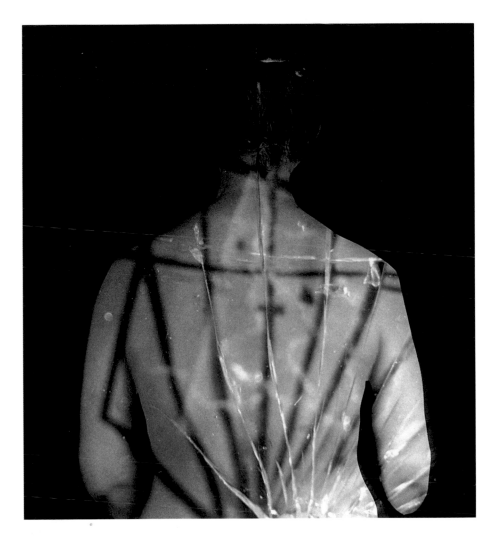

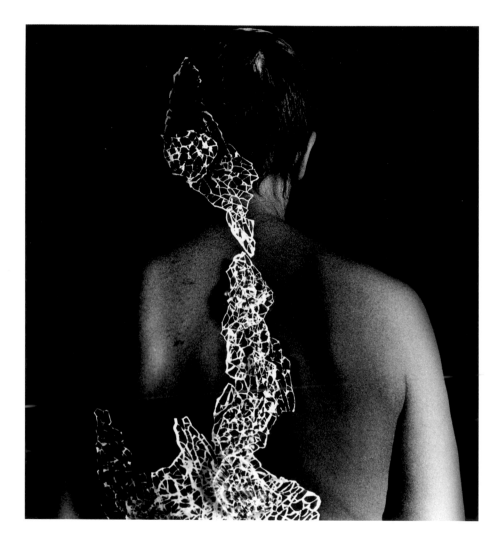

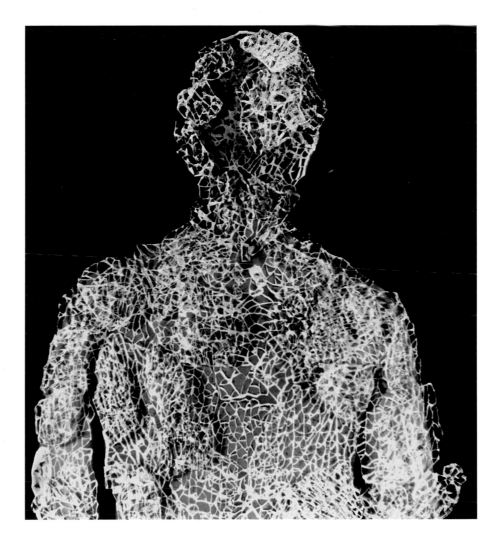

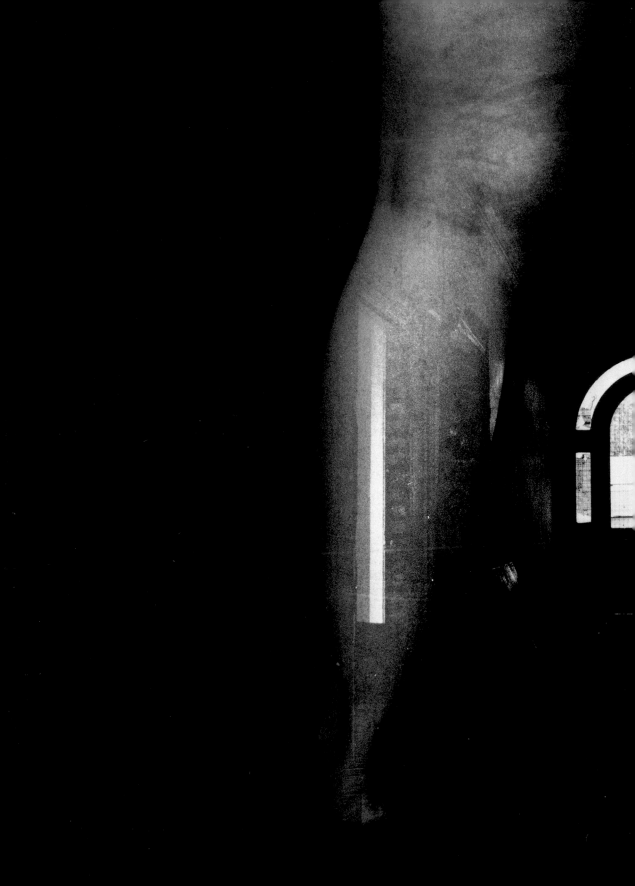

Unspeakable Pain
Doctor Charles Pither

'When the doctor and the physician agree about the problem, then the patient gets better' – Adolf Mayer

People suffering pain tend to consult their doctor. They want to tell him or her their symptoms and describe how they feel because they believe that by so doing the doctor will be able to diagnose the problem and rid them of their burden of suffering. On their first visit the person experiencing pain may not necessarily give a lengthy description of their symptoms: they expect the doctor will spot what is wrong even on first hearing. The patient wants certainty, treatment and closure. Interestingly enough so does the doctor!

The doctor has the task of unravelling the description of the pain and detecting physical signs to be able to reach a diagnosis. He may order tests to elucidate pathology and to eliminate the possibility of 'something serious'. Often the initial hypothesis will be correct, the tests will demonstrate an abnormality and treatment can proceed. If this is the case then the mind of the doctor switches from listening to the symptoms to just hearing them. The problem has changed from a diagnostic puzzle to a case of X or Y. The physiology and pathology now take precedence over the subjective experience: the person takes second place to the disease. Whilst this aspect may not necessarily be what the patient wants, it may not matter overly much if they are getting better and feel the doctor is in control.

Michael Balint [1] interpreted this interaction in terms of the patient 'offering' an illness and the doctor either accepting it or not. In the case above acceptance implies that the symptoms and signs add up to a formulation which is agreeable to both patient and doctor. Both the patient and doctor can move forward within a mutually satisfactory relationship.

Surprisingly often however, the script does not run like this. The symptoms are confusing, the signs equivocal or absent, tests negative, often repeatedly so, and no cause for the problem can be found. This may not be a problem if the symptoms settle, but what if they don't? Suppose the tests are all negative but the pain continues. What if the doctor can find nothing wrong, but the pain gets worse? The doctor, believing more in the 'hard facts' obtained from investigations, undermines the patients subjective account, and implies that the problem is not as bad as the person makes out, or that emotional problems are to be blamed. In essence the patient's proposition of illness has been rejected. The patient loses faith in this doctor and seeks a second opinion. How do they describe their symptoms to the next doctor? Will they give a cursory run through of their problems, or will they, perhaps, wish to emphasise this point or that, or stress how particularly severe the symptoms are in the hope that the doctor will not dismiss them as before and pick up the fact that they really do have a serious problem?

How might this exchange be influenced by ten years of pain, consultations with specialists too numerous to remember, and six failed treatments? Such is the lot of the typical patient with chronic pain referred to the INPUT unit at St Thomas's Hospital. How can this experience not alter the way the patient approaches the

next doctor? If the patient has felt dismissed by a previous doctor as 'imagining' their symptoms, how will this affect the way they recount their problems to the next?

Unfortunately a great many chronic pain sufferers have no definable lesion to account for their pain. Conventional treatment has by definition failed. They continue to suffer in spite of the best efforts of the medical system. Such a situation certainly does not imply that the pain is not 'real'. It is now clear that chronic pain causes degrees of suffering and limitation of quality of life worse than many better-defined diseases. Nor is it the case that that there is nothing physically causing the pain within the body. The experience of pain is virtually always caused by processes within the body, albeit that such processes are not identifiable or definable within current medical or psychological understanding. The concept of imaginary pain is untenable. One either has pain or one doesn't: pain is always real to the sufferer.

Chronic pain is a particularly destructive illness because its prolonged course adds to the burden borne by the sufferer. As the symptoms progress and medicine seems impotent to help, the woes and ills of the victim multiply and foment like rumours in a schoolroom. The 'physical' pains become embellished with distress, doubt and disquiet. Incapacity leads to joylessness. Pain and worry lead to sleeplessness. The seemingly endless catastrophe of existence fuels depression and helplessness. Ambition disintegrates alongside self-esteem. The consultation process becomes more fraught because the patient fights back both an admission of these features, and their tears, because they fear that once they show mental distress or 'weakness' their physical symptoms will be dismissed.

The doctor also has a problem within the consultation. His or her language and lexicography is medical and yet what they hear cannot be boxed into this framework. They cannot use it diagnostically and yet the situation demands more than providing sympathy. The pain sufferer does his or her best to describe the sensations and feelings that trouble them and that they are convinced are anchored in physical pathology. They struggle to find the words, and often say how difficult it is to describe what they feel. But how can any language ever find terms to describe the perturbations of neurology and psychology that underpin these essentially human 'feelings'? The events, situation and processing associated with them are always unique to the person. Why should language be able to effectively describe such experiences to another person? Effective communication always requires both parties to be speaking the same language. What if one person doesn't speak 'Chronic Pain'? Perhaps neither person speaks 'Chronic Pain'. The truth, as Virginia Woolf remarked is that *"the merest schoolgirl when she falls in love has Shakespeare and Keats to speak for her, let a sufferer try to describe a pain in his head and language at once runs dry."* Ultimately the lived experience of pain defies linguistics.

The starting point for this project was to explore whether adding a visual dimension to the language of chronic pain could help the interaction between a

person with pain and the professional sitting opposite. The resultant images published in this volume speak for themselves, and it is for the reader to judge whether they are moved or changed by the images.

From my perspective the endpoint is about a realisation that the consultation process can move from the conventional medical model to something of more value for both patient and doctor. I have come to appreciate that there can be another dimension to the crucial interaction between the two parties engaged in the consultation process. This can be seen as a translation of experience, and is essentially a transaction between the lived experience of the sufferer and the non-judgemental acceptance of these offerings by the physician. Balint's thesis is still tenable; doctor and patient need to establish mutual ground to find a way forward. The addition of a visual dimension can aid this process because it can allow both parties to image and share the problem from a second person perspective [2]. By finding time to share in the patient's journey a relationship can develop that can shift the doctor's role from that of enactor to facilitator, with both parties working together to reduce the impact the pain has on the individual. Perhaps the joke about the psychiatrist's advice to the obsessive is relevant to doctors treating those with chronic pain: 'don't just do some thing – stand there'!

Life, as Scott Peck asserts, is painful [3]. If my back is painful and I am out of work and my wife has left me, where do I hurt? When I am heart-broken where do I hurt? The age-old concept of sharing and talking about problems is increasingly denied the high tech medical environment in which doctors now practice. If doctors are to help pain sufferers who cannot be cured or eased by drugs or procedures, they have to relearn skills more familiar to alternative and primitive medical systems of listening and sharing. This construct aligns with the rubric of 'narratives' in medicine which has seen considerable interest and development in the recent years [4]. For me it is clear that adding a visual dimension to the narrative can aid communication of much of what somehow needs to be communicated by those with unspeakable pain, but yet cannot be said with words.

Charles E Pither FRCA
Consultant Pain Specialist, St Thomas's Hospital, London

References

1. Balint M *The doctor, his patient and the illness*, Second ed London 1964 Churchill Livingstone.
2. Sullivan M 1999 'Between First-Person And Third-Person Accounts Of Pain In Clinical Medicine' pps499-506 in Max M Ed. Pain 1999 An updated review. Refresher Course Syllabus IASP press.
3. Peck S *The Road Less Travelled* London 1990 Random House.
4. Greenhalgh T, Hurwitz B. *Narrative based Medicine*. London 1998 *BMJ*.

Acknowledgements

There are an enormous number of individuals and organisations too numerous to name here without whom neither the work nor the book could have been realised. I owe them all a deep debt of gratitude. The biggest thanks though must go to the chronic pain sufferers who agreed to take part. They shared their experiences with all of us with courage, honesty and creativity in order to help others.

I would like to thank the following organisations and their staff:

Novartis Pharma AG; INPUT Pain Management Unit St Thomas' Hospital; Guy's & St Thomas' Charitable Foundation; the Sciart Consortium (The Wellcome Trust, Calouste Gulbenkian Foundation, Arts Council of England, Scottish Arts Council, Nesta and the British Council); The Wellcome Trust, The Arts Council of England; Ketchum; The Royal College of Physicians; The Pain Society; Paintings in Hospitals; Millennium Images; Michael Dyer Associates; Display Graphics; London Picture Centre; Metro Imaging; Westminster Council; the Actors Benevolent Fund and the Equity Trust Fund; the staff at St.Thomas' Hospital; the staff at The Surgery, Hammersmith; the staff and students on the Foundation course at Chelsea College of Art and Design; the staff and students on the Fine Art course at Middlesex University.

I would like to thank in particular the following individuals:

Bergit Arends; Dr. Ken Arnold; Meg and James Baker; Roy Bass; Diana Beaven; Mary Bonner; Max and Megan Boothby; Phillipe and Anne Cherbonnier; Kelly Chorpening; Dr. Frances Cole; David Cross; Jo Desmond; Sebastien Desprez; Stephen Dwoskin; Lynn and Michael Dyer; Dr. Paula Fernandes; Prof. Renee Fox; Gina Glover; Gill Hancock; Thomas Heiser; Dr. Andrew Hodgkiss; Crispin Hughes; Prof. Brian Hurwitz; Marianne Jasmine; Nell Keddie; Lee Kershaw; Stephen King; Dewi Lewis; Penny Machin; Karen Mann; Peter Matthews; Elaine McClaren; Mike Messer; Alison Moon; Arabella Naylor; Fiona Padfield; Stacey Payne; Elizabeth Park; Dr. Charles Pither; Fred Pryor; Prof. Alan Radley; Miss Shanti Raju; Dr. Geof Rayner; Ruth Richardson; Sean Richardson; Saskia Sarginson; Tolkun Satybaeva; Gaye Saunders; Amanda Sefton; Jason Shenai; Dr. Colin Howard Sims; Verity Slater; Tansy Spinks; Mary Alice Stack; Kristine Stattin; Chris Stockbridge; Davina Thackara; Graham Treacher; Linda Turpin; Patrick Ubezio; Stephen Webster; Tony White; Jane Wildgoose; Dr. Amanda Williams; Celia Williams; Maggie Winkworth; Lucie Winterson; Susan Wright.